Editor
Sara Connolly

Editorial Project Manager
Elizabeth W. Morris, Ph.D.

Editor-in-Chief
Sharon Coan, M.S. Ed.

Cover Artist
Brenda DiAntonis

Art Manager
Kevin Barnes

Art Director
CJae Forshay

Imaging
Ralph Olmedo, Jr.

Product Manager
Phil Garcia

Publishers
Rachelle Cracchiolo, M.S. Ed.
Mary Dupuy Smith, M.S. Ed.

TIPS & TRICKS FOR USING

Digital Photography

Writing Prompts

Story-telling

Project Reports

and much more!

Author

Michael Lawrence

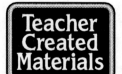

Teacher Created Materials, Inc.
6421 Industry Way
Westminster, CA 92683
www.teachercreated.com
ISBN-0-7439-3837-2
©2004 Teacher Created Materials, Inc.
Made in U.S.A.

TABLE OF CONTENTS

INTRODUCTION

Introduction

Digital photography is a powerful tool for educators. Lucky for us, classroom applications abound! And increasingly, digital photography is a hobby (application) that has become affordable and easy to learn. This book will review several tips and tricks to assist you in integrating digital photography into your elementary and middle school curriculum. If you are a high school or college level instructor, you may find value in many of these project ideas, as they can easily be adapted to serve the needs of all ages of students. This book is not only for those with digital cameras, because you don't need to have a digital camera to enjoy and utilize the lessons found inside. Any image that can be developed at your local store can be saved to a disk for an additional fee. If you have access to a scanner, you could also scan in any prints that you have already developed. There are even web sites that specialize in developing your 35mm film, mailing you the prints, then posting the images to the web for viewing and reorders.

The lessons in this book are presented in a consistent format for easy implementation, as follows:

- Brief Lesson Introduction
- Appropriate Grade Level(s)
- Appropriate Subject Area(s)
- Materials Needed
- Activities (steps 1, 2, 3, etc.)
- Examples or Samples

You'll also find Tips and Tricks as sidebars that provide valuable hints to make your projects even better.

With nearly all lessons, there are project examples to be found on the accompanying CD-ROM. These can be used as templates in your classroom.

What you will not find in this book are advanced photo editing techniques such as red-eye removal, manual exposure settings, time-lapse photography or QuickTime VR panorama-style movies. While scanners and other devices are mentioned as great tools to digitize photos, we will not discuss scanning techniques, or advanced settings. Features and functionality of digital cameras will be discussed throughout the book, but not specifically by manufacturer or model.

Before we jump into the nitty-gritty of the lessons, I thought it could be useful to provide you with a brief primer on digital photography concepts, tips on shopping for digital cameras and additional gadgets, and descriptions of graphic editing and presentation software mentioned in the book, as well as a quick overview of how to instruct students in the use of digital cameras.

INTRODUCTION

Digital Photography Concepts

Pixels, megapixels, resolution, media format, digital zoom, and USB; if these terms are unfamiliar to you, do not despair. Pixels are the dots of color that make up any digital image. Think of them as the tiny dots of light you can see if you lean very close to a color TV screen. You remember doing that as a kid, right? Blue, green and red dots of color seemed to magically meld together to form the image of Johnny Carson, the Pillsbury Doughboy, Mr. Rogers, or even the MTV "Moon-man." These are the same kinds of dots that make up digital images. They are referenced as numerical values in a width-by-height measurement. For instance, the computer screen I am currently typing this page on displays 1024 x 768 pixels on my monitor. This is often referred to as dots per inch, or "dpi." Digital purists may even refer to it as "ppi" to correctly identify the dots as actual pixels per inch. This size choice is referred to as "resolution." Early digital cameras could only shoot images at one resolution, 640 x 480. This is a sufficient resolution for popping images into PowerPoint, Hyperstudio, or posting to the web. However, when you actually print them from your computer, these images are clearly inferior to standard 35 mm prints.

The term "megapixel" is a numerical value, computed by multiplying the width by the height. If the resulting number is around one million, you've got 1 Megapixel! Camera companies are rapidly working on increasing this number, and we are now at a point at which the highest resolution digital camera images rival 35mm images in quality, detail and color reliability. Keep in mind, however, the larger the resolution, the larger the file size of the digital image (see figure 1 for a rough approximation). The big advantage of digital, of course, is that these raw images are always the same quality. There's no loss from your original to any number of copies you wish to print. You can burn a CD, e-mail a friend, or post them to the web without ANY loss of quality (sometimes referred to as "generational loss").

Image size (pixels)	8MB	16MB
640 x 480	72	147
800 x 600	50	100
1024 x 768 (1 megapixel)	34	69
1280 x 960 (1.2 megapixel)	16	31
1600 x 1200 (2 megapixel)	8	16
2048 x 1536 (3 megapixel)	3-5	8-10

Figure 1

INTRODUCTION

Digital Photography Concepts *(cont.)*

As the technology advanced, and digital cameras became popular, consumers and professionals alike demanded better quality resolution from their cameras. And the digital camera industry quickly responded. Currently, five-, six- or even seven- megapixel cameras are available for the high-end professionals. Such cameras cost thousands of dollars, however. This is a huge benefit for education. "Why?", you ask. The professional users of these state-of-the-art cameras drive down the cost of the lower resolution cameras (two-, three-, and four-megapixel cameras) to affordable ranges. Educators, PTA groups, foundations, and yes, even teachers can now wrangle together enough funds to get one of these lower resolution cameras for general school and classroom use. The upshot is that we're not sacrificing too much in the way of quality in terms of printing either. A two-megapixel image has just enough resolution to print a beautiful 8" x 10" glossy photo on a regular inkjet printer. The most expensive part of this equation is the special photo quality paper which can sometimes run as much as $1 per page. For most classroom projects (and every project in this book), 8" x 10" is more than enough. The chart illustrates minimum size requirements for most of the common photo print sizes (see fig. 2).

One thing often forgotten in the use of digital photography is that the project does not have to start with a digital camera. Nearly every 35mm film developing service (even your local grocery store) will develop your photos AND return digital copies of your prints for a fee. In some cases, they'll even save multiple resolutions of your images (high, medium and low resolutions) for print, presentation and email, respectively. This is something to consider before purchasing an expensive digital camera when you have a perfectly useful 35mm camera. This approach can get expensive as well, but if you are looking for the best of both worlds (print quality and digital functionality), you may want to consider this option. There are now even digital disposable cameras that are dropped into the slot at your local store just like regular disposable cameras. For all of these reasons, every lesson in this book could be done with *either* a digital or a film-based camera.

Print size (inches)	Resolution (pixels)
wallet	640 x 480
4 x 5	768 x 512
5 x 7	1152 x 768
8 x 10	1536 x 1024

Figure 2

INTRODUCTION

Shopping for a Digital Camera

Digital cameras are promoted, priced and advertised based on the features and tools built into the camera. Over the years, I've collected some advice to offer when shopping for a digital camera:

1. Buy a camera that offers you the resolution you need. Don't be lured by the more expensive, high-quality four- or five-megapixel cameras, if you are only going to be printing snapshots for your classroom, or inserting images into presentation software. If you teach or are the advisor for journalism, yearbook, or other print-heavy subject, you may be the exception to this advice. If you have the funding for it, go for as many pixels as you can get.

2. Only pay attention to the camera's "optical zoom," as "digital zoom" values are virtually useless. This is an interesting development in digital camera marketing. Manufacturers are using digital zoom to deceptively inflate the zoom amount (usually a number followed by an 'x' to represent the amount of magnification you can obtain on a given camera). Optical zoom matters because it represents the amount of magnification your camera lens can actually offer. Digital zoom merely blows up the same pixels to create a closer, but blurrier view of a subject (see fig. 3 for an example of optical vs. digital zoom). Not quite worth the hullabaloo, in my opinion. Somewhere on the camera box, or on the web site for the camera, there should be distinction between optical and digital zoom ratings for the camera. A good educational digital camera should have a 2x or 3x optical zoom. More is great, but for most classroom uses, not necessary.

3. Buy a bag with padding for the camera. The more pockets, the better. Someone, and it may just be you, will eventually drop the camera. Better to keep it in a padded bag when this happens. This tip becomes especially pertinent if you plan on sharing the camera between teachers, grade levels or schools. Pockets are invaluable for storing extra batteries, media cards, chargers, etc.

Figure 3

INTRODUCTION

Shopping for a Digital Camera *(cont.)*

4. Buy extra batteries. If the camera comes with a rechargeable proprietary battery, buy an extra one. If it uses AA, or another standard type of battery, buy rechargeable versions of these. Most schools are not well set up to reimburse teachers for consumables like batteries, so it's best to buy rechargeable ones at the same time the camera is bought. You might also find that the batteries for your particular camera eventually become unavailable due to obsolescence or other changes in the market.

5. Buy extra storage media. Most cameras come with one small capacity digital media storage card. These come in many formats (see fig. 4). Your camera will only use one of these types of media, so it's best to buy a second card of larger capacity to allow you to switch them when the first, smaller card fills up. This is especially important if you plan on taking your digital camera on field trips or other activities far away from a computer. The most common storage format used in digital cameras is currently Compact Flash (CF).

6. Choose a camera with video-out capability. This may not be available for some models, but if you can get it, I'd recommend it. This feature allows you to view your digital images on your television, record a slideshow, or even use your camera as an overhead document camera for instructing students in close-up activities.

Other Useful Gadgets

35mm Camera

Yes, you can still use your trusty 35mm camera to get digital images! When you take your film to be developed, check the box on the package for photo disk or CD-ROM, or something along those lines. This will cost a little bit extra, but the bonus is that you that get beautiful prints *and* digital images—the best of both worlds!

Scanners

You can use a scanner to digitize any non-digital photos, slides or negatives, sometimes two or more at a time. This is great if you don't have a digital camera, but would like your prints digitized for editing, emailing or presentation.

Figure 4

INTRODUCTION

Other Useful Gadgets *(cont.)*

Color Printers Inkjet (good), Solid Ink, or Laser (best)

Despite the fact that inkjet printers are cheaper to buy, solid ink or laser printers are cheaper in the long run (and create better looking images).

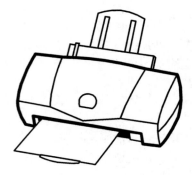

Media (or card) Readers

These are useful tools for bringing digital images onto your computer. Most digital cameras do not require an additional card reader, but having one can give you added flexibility for classroom use.

LCD Projectors, or Digital Projectors (DP)

These projectors allow you to show your slideshow presentation, video or digital images onto a screen. While they have historically been too expensive for most schools, prices have just recently dropped under the $1000 mark. Lumens (brightness) and resolution are the two key factors in shopping for one (the higher the better). Two other contributing factors should be price and weight (the lower the better). The final contributing factor to consider is resolution. Just like cameras or scanners, projectors come in a range of pixel depths. The lowest resolution I'd recommend is SVGA (800 x 600). XGA is one step higher (1024 x 768), and worth the additional price.

Tripod

Not only do these steady your camera when lining up a shot, but these can also prevent accidental drops. Get the kind with a central stabilizing rod. These are also very helpful in situations with low light, or when you cannot use a flash. It's difficult to avoid a blurry shot in these situations, but a tripod can make all the difference. **Pedcopods.com** even makes compact, tabletop tripods for around $21.

Other Useful Gadgets *(cont.)*

TV, VCR (and blank tapes)

You can present a slideshow of your images for recording. Some computers will require a scan converter to translate your computer's video signal into a television signal. These run between $70–150.

CD burners (and blank CD-R discs)

With a CD burner, you can make photo CDs, or videodiscs of your presentations.

DVD burners (and blank DVD-R discs)

A neat way to share movies, images and slideshows, DVDs are becoming the standard delivery tool for movies (from home, or from Hollywood). In fact, they've surpassed VHS tapes in rentals!

Buying software for yourself

Most software companies offer "academic" versions of their major applications. These are identical to the retail versions, except they are usually sold at half the price, or less. To be eligible, you need only prove that you are a student or, you guessed it, an educator. In fact, most academic software vendors (**creationengine.com**, **journeyed.com**, **acornmedia.net**, to name a few) offer this pricing to ANY school employee (yes, custodians can buy *Photoshop* for cheap too!). So when you are looking to buy software for yourself, don't pay retail! There are even cheaper volume-licensing deals for educational institutions buying software. You may think the software companies do this out of the kindness of their hearts, but they actually do it to give themselves legal footing to prosecute those schools, districts or individual teachers that illegally copy (or pirate) software. If they offer such great discounted pricing for educators, there's no justification for the schools not to following proper licensing agreements! A great resource for software licensing questions is Hall Davidson's copyright chart for educators

http:www.halldavidson.net/downloads.html

INTRODUCTION

Copyright and Intellectual Property

Teachers working with photography, video and other copyrighted works will often have a fuzzy understanding of copyright law and fair use guidelines. If this describes you, do not be alarmed. The U.S. Constitution keeps copyright deliberately vague to give educators and others freedom to "promote science and the useful arts." The following information provides very quick points to keep in mind when using works for which you do not hold copyright.

1. Use valid (legal) copies for your classroom projects. The Fair Use guidelines release educators from infringement when using copyrighted works in their classroom, only so long as they are purchased legally. This means that students (or teachers) bringing in pirated music for classroom projects are not protected. It has to be a school or individually bought copy of the work (CD, video, etc.). This is also true of software licenses.

2. Use copyrighted work only for curriculum projects—not entertainment. Another stipulation in the Fair Use guidelines specifically requires that copyrighted work be used in a curricular capacity, not for entertainment or reward. In other words, you CANNOT show that great Disney movie in the multipurpose room for students with perfect attendance.

3. Do not republish others' works. This includes CDs, DVDs, VHS tapes, the web, and local TV stations. Since the 1980s, everything you publish is automatically copyrighted by the publisher (in this case, you).

4. Do not resell copyrighted work. This is inherent in the point above, but it is worth repeating. It would seem as though raising money by selling a student-produced video slideshow with cool, popular music would be protected. But it's not. You are violating copyright by selling someone else's work (namely the artist whose music provides the background ambiance) as your own. Yes, even for a non-profit or educational institution. Only if it was original art and music created by you and your students could you do it.

INTRODUCTION

Instructing Students on Digital Camera Use

Students are surprisingly careful with digital cameras. In fact, in my experience, it is more often the teacher that breaks technical equipment than the students. That said, there are a few tips I'd offer to anyone planning on using digital cameras with elementary school students.

First, always use the strap. Every digital camera comes with some form of wrist or neck strap. Use it. Have the students use it. If you don't model this behavior, it's much harder to train the students to use it. I actually will take time in front of my students and walk them through how to hold, aim, shoot, and most importantly, hand off the camera. It's usually during the "hand off" step that a camera is dropped. I teach students to have one partner hold the camera while the other moves the strap onto him/herself, and THEN hand off the camera. That way, there are always two hands holding the camera.

Second, teach your students how to safely turn the camera on and off. You don't want them taking pictures and then quickly turning off the camera. This can damage the memory card and lose photos.

Third, show your students how to line up a shot, steady the camera with one hand, and gently press halfway down on the shutter button to focus a shot. Then, and only then, should they take a picture. Otherwise, you'll have many blurry or poorly lit images.

Finally, demonstrate to your students how to save battery life. If you have a camera that uses AA or AAA batteries, you're going to want them to last as long as possible. A simple way to save about 50% of your battery life is to turn off the LCD screen on the back (if your camera has one). Your students can line up the shot through the viewfinder, only turning on the camera to check the photo for blinks or other errors.

One more good idea is to have your students become responsible for this instruction. In my classes, I would identify two students to act as digital camera monitors. These are students that I've already instructed on proper camera handling and use. These students then teach the other students how to handle and use the camera correctly before they begin using it for a project.

INTRODUCTION

Final Word

I am sure you will enjoy this book. Digital photography can be a wonderful enhancement to any curriculum, and it's only going to get better. On the accompanying CD-ROM, you will find samples, templates and other tools to get you moving in the right direction. I've also listed online resources that can help you in your integration of digital photography in your classroom. Many of the lessons presented can be adapted to suit your needs. I encourage you to try your own spin on these lessons.

Feel free to explore, and find new and exciting techniques!

USING DIGITAL IMAGES WITH SPECIFIC APPLICATIONS

Using digital images with other applications is a fun way to support the teaching in your classroom. Almost any authoring application you have on your computer will support the use of digital images including *Microsoft PowerPoint, Excel, Word,* and *Publisher; AppleWorks, Kidspiration, Inspiration* and even *Kid Pix!*

The method of inserting digital images into each of these applications is different. What follows here are directions for inserting digital images into several popular applications, several of which you probably have on your computers at school. If your application is not listed here, you should be able to easily find directions using the Help menu right from within the program.

Before starting with any application, make sure you know where your digital images are stored. Perhaps you have transferred them from your digital camera and they are in a folder on your hard drive. If you have a server at your school, maybe you have stored them there. You might even have them saved on a floppy disk. It doesn't really matter where they are saved—you just need to know where they are!

Using Digital Images with *Microsoft Word*

Inserting digital images into a word processing document is an easy way to add interest and great content to your or your students' work. Students can add pictures to a report, you can spice up your worksheets, or even create a class photo album!

To insert a picture into a *Word* document, begin with the **Insert-Picture-From File** menu command.

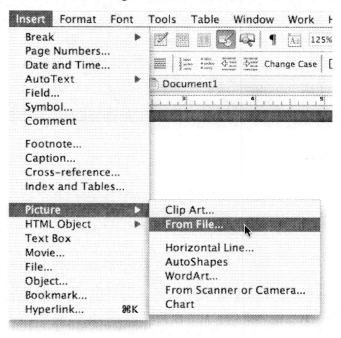

In the resulting **Choose a Picture** dialog box, locate the desired picture in your directory structure and click on Insert. If you want to add the picture directly from your camera or scanner, make sure it is connected to your computer, and then use the **Insert-Picture-From Scanner or Camera** menu command. You can also add Clip Art images from the built-in clip art library using the **Insert-Picture-Clip Art** menu command.

USING DIGITAL IMAGES WITH MICROSOFT WORD

After adding the picture, you might want to change the way the picture interacts with the rest of your document (text, other pictures, etc.) *Microsoft Word* gives you lots of control over the properties of your picture so you can have your document look just the way you want. To access this control, click once on your picture to select it, and then use the **Format-Picture** menu command.

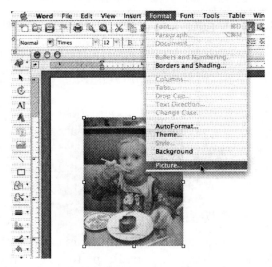

You are now presented with the Format Picture dialog box that allows you to choose several options for controlling how your picture interacts on the page. You can click on the **Colors and Lines** tab to add a border to your picture; on the **Size** tab to change the size or rotate your picture; or on the **Picture** tab to crop or change the contrast/brightness of your picture.

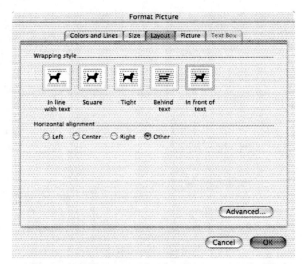

The tab you and your students will most often use is the **Layout** tab. Using this tab, you can choose to have text wrap around your picture, or have your picture float in front of or behind the text on the page. Under Wrapping style, clicking on **Square** or **Tight** will allow text to wrap around the picture. Clicking on **Behind text** or **In front of text** allows your picture to float in your document independent of the text. And finally, clicking on **In line** with text places the picture directly inline with your text, as if you had "typed" it from the keyboard. Using this option, your picture behaves identical to any other text character. Using this option gives you the least amount of flexibility in terms of placing your picture in your document.

USING DIGITAL IMAGES WITH MICROSOFT POWERPOINT

If you create presentations in *PowerPoint*, using your own digital images adds a personal touch and ownership to the project. If your students can add the field trip pictures from the zoo or the scanned pictures of their family, the interest factor and learning curve will naturally be higher!

To insert a picture into a *PowerPoint* document, begin with the **Insert-Picture-From File** menu command.

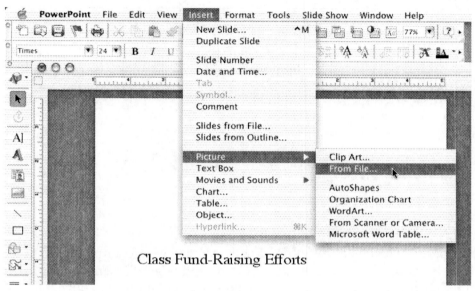

Class Fund-Raising Efforts

In the resulting **Choose a Picture** dialog box, locate the desired picture in your directory structure and click on Insert. If you want to add the picture directly from your camera or scanner, make sure it is connected to your computer, and then use the **Insert-Picture-From Scanner or Camera** menu command. You can also add Clip Art images from the built-in clip art library using the **Insert-Picture-Clip Art** menu command.

If you like, you can change some of the picture's attributes after adding it to your *PowerPoint* presentation. To do this, click once on your picture to select it, and then use the **Format-Picture** menu command.

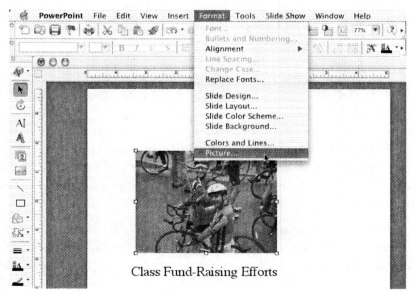

Class Fund-Raising Efforts

You can now use the resulting Format Picture dialog box to change your picture's attributes. You can click on the **Picture** tab to crop or change the contrast/brightness of your picture; on the **Position** tab to fine tune the placement of your picture on the slide; on the Size tab to change the size or rotate your picture; and on the **Colors and Lines** tab to add a border to your picture or change the transparency.

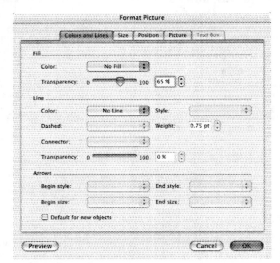

Changing the transparency can be a useful feature, as you can give your picture a "watermark" effect and then use it as a background for your slide, with text and other elements on top. This is a wonderful way to add topic or curriculum-specific detail to your *PowerPoint* presentations.

In addition, after adding a picture to your *PowerPoint* presentation, you can add an "animation effect," which will allow your picture to appear on your slide with a mouse click. You can choose from several different entry effects. Depending on the version of *PowerPoint* you have, this technique is accomplished differently. In most versions of *PowerPoint*, you can start this process using the **Slide Show-Custom Animation** or **Slide Show-Animations** menu commands.

You can also add hyperlinks to your pictures in *PowerPoint*! When a hyperlinked picture is clicked, the user can be taken to another slide, to a web page, or even have the picture play a sound. This feature is available via the **Slide-Show** Action Settings menu command.

USING DIGITAL IMAGES WITH MICROSOFT EXCEL

Although digital images and spreadsheets are often not thought of in the same sentence, there are several ways to add utility to your spreadsheet documents with pictures you or your students have taken! You can simply add a picture to your spreadsheet to enhance the curriculum connection, use pictures as data markers or chart areas, or even use a picture as the background for your document.

Adding a picture to an *Excel* document is accomplished the same way as with *Word* and *PowerPoint* via the **Insert-Picture-From File** menu command, and then choosing the desired picture.

You can also use digital photos in *Excel* for certain types of data markers, the chart area, the plot area, or the legend in 2-D and 3-D charts, or the walls and floor in 3-D charts. With this procedure, you can use a picture for the data markers in column, bar, area, bubble, 3-D line, and filled radar charts. To accomplish this, follow these steps:

1. Double-click the chart item that you want to use a picture for.

2. Click on the **Patterns** tab, then on **Fill Effects**, and then click the **Picture tab**.

3. Click Select Picture.

4. Locate and double-click the picture you want.

5. On the Picture tab, select the options you want, and click **OK**.

6. Click **OK**.

Your chosen picture is now in your *Excel* chart! This is a fun way to customize your graphs to more closely support the curriculum connection.

A seldom used but equally effective use for a digital photo in an *Excel* document is as a background pattern for a worksheet. This is easily done—just use the **Format-Sheet-Background** menu command and choose the picture you want as the background. The picture is repeated to fill the sheet.

USING DIGITAL IMAGES WITH INSPIRATION

Inspiration is one of the easiest programs to tie into almost any curriculum area you might teach. *Inspiration* can be used to brainstorm, plan, organize, outline, diagram, and write. Although *Inspiration* includes a wonderful library of graphic symbols, including photographs, you can further enhance the curriculum connection using your own digital photos. You can either insert your photos directly into an Inspiration document, or create your own custom symbol library containing many of your photos.

Let's look first at how to insert a picture directly into your document. If you want your inserted graphic to replace an existing symbol, select that symbol first by clicking once on it. If you want your picture to be added as a new symbol, click on any white space in your document before continuing. To insert a picture into an Inspiration document, start with the **Edit-Insert Graphic** menu command.

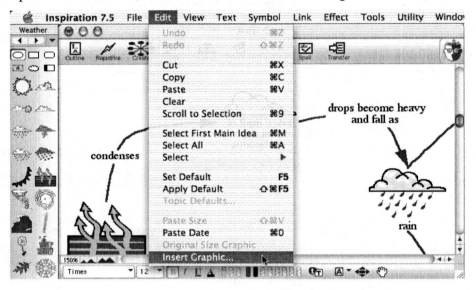

In the **Open:Inspiration** dialog box, locate the picture you want to insert and click on **Open**. Your picture appears in your *Inspiration* document as shown below.

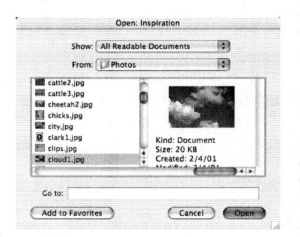 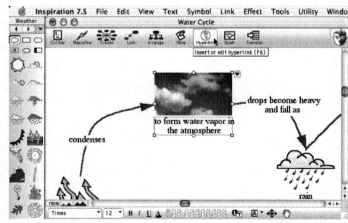

You can move your picture by clicking and dragging on it, or resize it by clicking and dragging any corner handle. Like in *PowerPoint*, *Word* and *Excel*, you can create a hyperlink from your picture to many other things. You can hyperlink your picture to another *Inspiration* document, a web site, or any other document (for example, a *PowerPoint* presentation.) To do this, click once on your picture to select it, and then click on the **Hyperlink** button in the upper toolbar as shown above.

USING DIGITAL IMAGES WITH INSPIRATION

In the resulting Hyperlink dialog box, you can choose to link to a web page, a file, another *Inspiration* document, or even an email address. In the latter case, clicking on your picture will result in your email application opening with an email addressed to the recipient you entered, ready for composing.

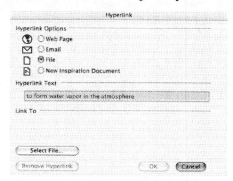

Another powerful use of digital photos in *Inspiration* is the creation of custom symbol libraries. You can place several related photos (for example, all the pictures of your students) in a single custom symbol library. This library would then be available to anyone using *Inspiration*. You can even easily replicate the library for use on other computers. To create your own custom library in *Inspiration*, follow these steps:

1. Go to the **Utility-New Symbol Library** menu command. In the **Add New Library** dialog box, choose a category from the pull down menu and type in a name for your new library. Click on **OK**.

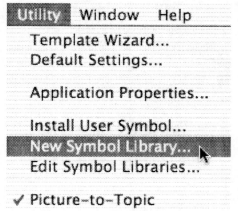 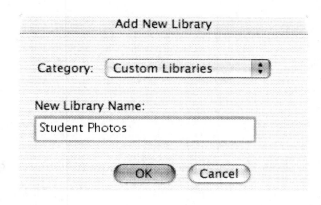

2. Your new symbol library appears in the Symbol Palette. Go to the **Utility-Edit Symbol Libraries** menu command.

 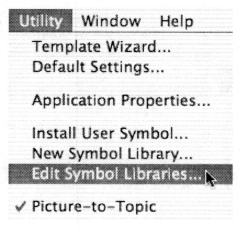

4. Choose your symbol library from the drop down menu. Click on **Import Graphic**.

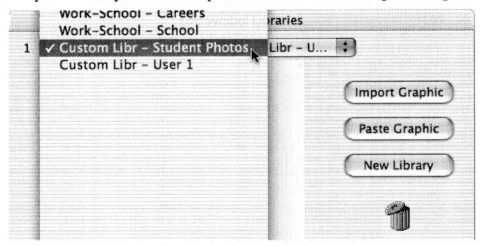

5. Locate the first picture and click on **Open**. Click on **OK** to install the picture as the Standard Symbol Size. Click on **OK**.

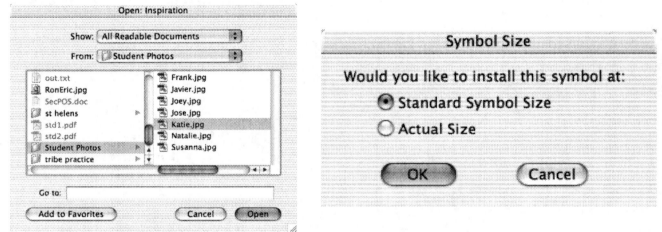

6. Your digital photograph is now in your new custom library!

7. Repeat steps 6–8 to install additional pictures.

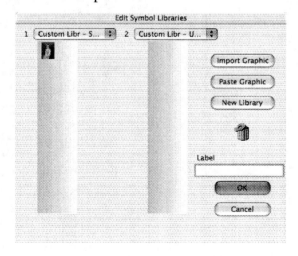

USING DIGITAL IMAGES WITH KIDSPIRATION

Similar to *Inspiration*, *Kidspiration* is easy to tie into almost any curriculum area you might teach. *Kidspiration* can be used to brainstorm, plan, organize, outline, diagram, and write. Also like *Inspiration*, *Kidspiration* contains many curricular-related symbols. However, there will be times when you want to include your own photos to personalize your documents or to better connect them to your curriculum. You can insert your photos directly into a *Kidspiration* document, or create your own libraries containing your photos.

Let's look first at how to insert a picture directly into your document. If you want your inserted graphic to replace an existing symbol, select that symbol first by clicking once on it. If you want your picture to be added as a new symbol, click on any white space in your document before continuing. Use the **File-Import a Graphic** menu command, and locate the picture you want in the **Open:***Kidspiration* dialog box. Click on **Open** when you have decided on your picture.

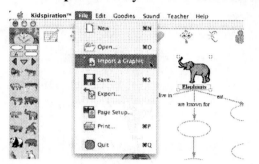

After your picture appears in your document, you can resize it by clicking on any corner handle and dragging. You can also add text in the text field that is at the bottom of your photo.

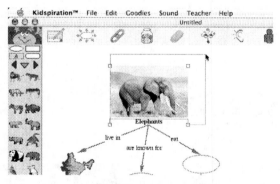

Did you know that you can also record a sound and attach it to your imported picture in *Kidspiration*? This can be a great way to annotate the digital photos you insert into *Kidspiration* documents. Start by clicking once on your picture to select it. Then use the **Sound-Record** menu command to bring up the Record dialog box.

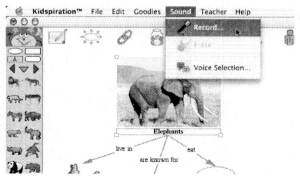

USING DIGITAL IMAGES WITH KIDSPIRATION

In the record dialog box, click on the **Record** button and begin speaking. When you are done, click on the **Stop** button. You can click on the **Play** button to preview the sound if you like. When you are satisfied with your recording, click on **Save**. Back in your *Kidspiration* document, you will notice that your picture now has a small speaker icon in the upper right hand corner. By clicking on this icon, you will hear your recording played back!

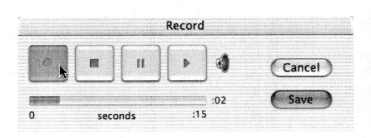

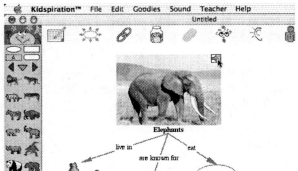

Just like in *Inspiration*, you can create your own digital photo custom symbol libraries. This is a great way to collect several pictures of a similar theme into one place for use in your *Kidspiration* documents. Follow these steps to create your own *Kidspiration* custom library!

1. Go to the **Teacher-Enable Teacher** menu. Then use the **Teacher-New Symbol Library** menu to bring up the Add New Library dialog box.

2. In the Add New Library dialog box, choose a category, type in a name for your new library, and click OK. Then use the **Teacher-Edit Symbol Libraries** menu to bring up the **Edit Symbol Libraries** dialog box.

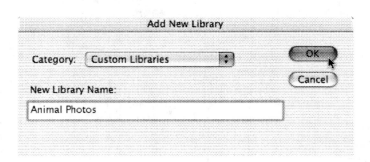

3. In the **Edit Symbol Libraries** dialog box, use the pull down menu to choose the library you just created and then click on **Import Graphic**. In the **Open:***Kidspiration* dialog box, select the picture you want and then click on **Open**.

4. Choose **Standard Symbol Size** in the Symbol Size dialog box and click on **OK**. You'll now see your photo in the library in the Edit Symbol Libraries dialog box. You can type a label for your picture if you like. Repeat step 3 for each picture you want to add to your library. When you are done, click on **OK**.

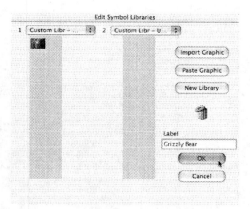

5. You'll notice your picture(s) are in your symbol library ready for your use!

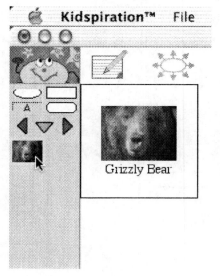

USING DIGITAL IMAGES WITH HYPERSTUDIO

HyperStudio is an application that allows all your students to work at their technological level. A *HyperStudio* project can be a simple document that contains just a few cards, or one organized in a very complex manner. No matter what the level of your students' projects, the use of digital photos in *HyperStudio* can certainly help integrate technology into your curriculum!

To insert a picture into a *HyperStudio* stack, start with the **Objects-Add a Graphic Object** menu. In the resulting dialog box, choose the picture you want and then click **Open**.

You will now see the Graphic Objects dialog box. Here you can use select tools to select the portion of the graphic you want. You might have to use the scroll bars to see the entire graphic. Click on **OK** when you are done selecting the graphic and your graphic will appear on your card. Click anywhere outside of the graphic.

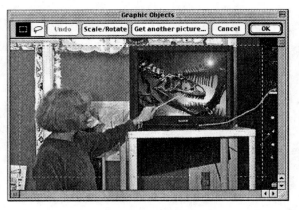

In the Graphic Appearance dialog box you can use the Actions button to assign various actions to your picture (playing a sound, going to another card, etc.) When you are ready, click on **OK**. Your picture is now on your card!

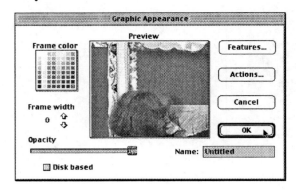

USING DIGITAL IMAGES WITH APPLEWORKS

AppleWorks is a very versatile program, with word processing, spreadsheet, drawing, painting, database and presentation modules. Although you can insert pictures into any of the modules, we will look at the three most commonly used ones—word processing, drawing and painting.

In an *AppleWorks* word processing document, you can insert pictures to include in your written reports, add captions to your pictures, or just make a simple photo album. To begin the process, make sure you have clicked on the **Draw Tool** (arrow pointer) before you insert the picture. Use the **File-Insert** menu to bring up the **Open:***AppleWorks* dialog box.

Using the drop-down menu, change the File Format to **All Available** and then choose the picture you want to insert. Click on **Insert** when you are done, and your picture appears in your document! You can now add text if you like, or move and/or resize your picture. To move your picture, click on it and drag. To resize it, click on a corner handle and drag.

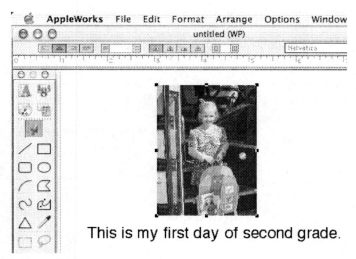

This is my first day of second grade.

DIGITAL PHOTOS AND DRAWING IN APPLEWORKS

The Drawing environment is a great place to work with digital photographs in *AppleWorks*. You have lots of flexibility with text and images and the way they interact with each other. If you are creating a document that will contain many images, you might consider a Drawing over a Word Processing document.

To insert a photo into a Drawing document, use the **File-Insert** menu to bring up the **Open:** *AppleWorks* dialog box, just as with Word Processing. Using the drop-down menu, change the File Format to All Available and then choose the picture you want to insert. Click on **Insert** when you are done, and your picture appears in your document.

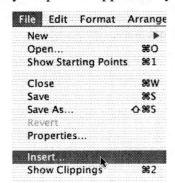 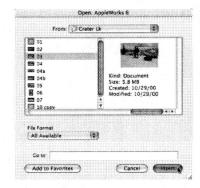

If you would like to add text to your document, click on the text tool. Now move the mouse into your document and click, hold and drag to create the text frame that will hold your text.

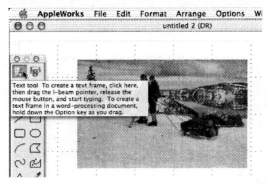

You can now just type, and your text appears in the text frame. You will also find that you can resize and drag your text frame around using the Arrow Pointer tool. This is one of the advantages of using the Drawing environment—unlike Word Processing, you can easily move your text around just like your pictures!

This is our trip around Crater Lake.

DIGITAL PHOTOS AND PAINTING IN APPLEWORKS

The Painting module handles photos quite differently than the Word Processing or Drawing environments. In Painting, photos become bit-mapped images and cannot be easily resized or placed on top of one another. In contrast, photos in Word Processing and Drawing are object-oriented and can be resized, moved easily and layered on top of one another. However, a photo in Painting can be edited using the eraser, pencil or other painting tools. Your students can alter their pictures (for better or worse!) or even edit pictures of themselves into historical photographs!

To insert a picture into a Painting document, use the **File-Insert** menu to bring up the **Open:** *AppleWorks* dialog box, just as with Word Processing and Drawing. Using the drop-down menu, change the **File** Format to **All Available** and then choose the picture you want to insert. Click on **Insert** when you are done, and your picture appears in your document.

If you would like to add text to your painting document, click on the **Text tool**, and then click, hold and drag in your Painting document to create the text frame to hold your typed text. Remember however, that the text you type will behave just like your picture in a Painting document-it is bit-mapped (it is no longer editable text—you need to use the eraser to delete it, or the selection tool to move it around).

DIGITAL PHOTOS AND KID PIX STUDIO DELUXE

And yes, you can even insert your digital photographs into *Kid Pix*! The screenshots provided below are for the *Kid Pix Studio Deluxe* version, but notes are included for the newest version of *Kid Pix*, *Kid Pix Deluxe 3*.

Use the **File-Import a Graphic** menu command (in *Kid Pix Deluxe 3*, the menu command is **Add-Add a Graphic**) to bring up the Import a Graphic dialog box. Choose the picture you want to import. Before clicking on Open, notice you have some options under the preview window-you can rotate your picture before you insert it (you can't rotate after insertion) and choose from some other options as well. Experiment with these to see which one works best for you. Generally, Scale Manually works quite well.

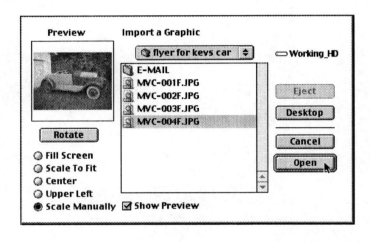

After clicking on **Open**, the picture appears in your *Kid Pix* document. You can now use the *Kid Pix* tools to enhance and or label your picture.

CLASSROOM SLIDESHOW

Introduction

This is a fun, retrospective activity in which photos can be placed into a photomontage and presented. Try this activity after a curricular unit, field trip, or other class or school event. Assign a class historian or a parent volunteer to snap the photos throughout the unit. Then, sort, edit (when necessary) and place the photos into a presentation.

Appropriate Grade Level(s):

All

Subject Area(s):

All

Materials Needed:

Hardware: Camera (digital or 35mm), computer, TV (VCR optional) or LCD Projector (and screen), and necessary cables. NOTE: Some computers may require an additional scan converter to connect to the TV or VCR.

Software: *iMovie or Kai's Power Show* (or other presentation software), optional—*Photoshop Elements* (or other image-editing software).

Activities:

1. Take photos of your event, being careful to include every member of the class at least twice, to give you some editing choices.

2. If you have a digital camera—upload the photos to your computer. If you are using a 35 mm camera, you can either have your photos developed and put onto CD, or scan them in using a scanner.

3. Edit your photos (removing red eye, rotating 90°, cropping, etc.).

Open House

This is a great activity for Back-to-School night, Open House, or an end-of-year event. Set up your slideshow to loop while your parents are gathering.

Some cameras (like the Nikon Coolpix, and the Canon Powershot) have a built-in feature that allows for slideshow playback on your TV or VCR. If your camera has TV or A/V out, it's likely to have this feature.

CLASSROOM SLIDESHOW

4. Using one of the presentation software packages (for example, *Kai's Power Show or iMovie*), insert your photos.

5. Arrange them as needed.

6. Set the duration for each photo to between 3-6 seconds. Try out different speeds to see what works for you, but keep in mind, most peoples' attention span for this sort of slideshow wanes after about 4–5 minutes, often less.

7. Add appropriate music to your presentation. You will be amazed how much better your presentation looks once you've added fun music. If you plan on publishing your video to the web, remember to follow proper copyright guidelines and avoid using music for which you are not a copyright holder. See the following page for more suggestions for including music in your slideshow.

8. Add subtitles, transitions and effects (if your presentation software includes these options). Although you may be tempted to use all the coolest transitions between every picture, you may want to utilize a standard cross-fade technique for the majority of your transitions. It really improves the professionalism of your finished slideshow.

9. Plug your computer into a TV or digital projector, fire up the popcorn, and present your masterpiece!

CLASSROOM SLIDESHOW

Record Your Slide Show

While a VCR is not necessary, if you have one, you could record your slideshow for future viewing or distribution. This is a great way to communicate with parents, the community and the school at large. One idea is to ask each parent to donate a blank VHS tape, then throughout the year, record these slideshows onto each student's tape. As this can be time consuming, you may want to appoint a student as "tape-master" to handle tape switching. At the end of the year, you can play all of them and then the tape goes home with students for a big home film festival!

Royalty-Free Music

Want to avoid hassles with copyright-protected music? Looking for a song that's just the right length for your slideshow? Make your own royalty-free music! Smartsound makes a great program called Movie Maestro (www.smartsound.com —$49.95 Mac/Win) that will create music to your specifications (samba, bossa nova, rock, classical, etc.) at the exact length you need it. You can download a trial version and use it for 30 days!

More Free Music

Looking for more free music for your slideshow? Try www.freeplaymusic.com for downloadable MP3 or WAV format music in 10, 20, 30 second lengths! You can even download a full minute version of hundreds of songs. Just pick your album, right-click (or Control-click on the Mac) on the title, format and length you'd like. Insert it into your slideshow, and shazam! Instant royalty-free music.

iTunes

Mac OS X users—the iTunes Music Store is now open for business! What does this mean for your slideshow? Every song you buy through the iTunes Music Store (usually only $.99 each) includes performance rights for your copy of the music. This means that if you REALLY, REALLY want to include *Don't Worry, Be Happy* as background music for your students' slideshow, you can now publish it to the web, broadcast it on your local cable station, or sell tapes as a school fundraiser! It's legal!

Our Classroom Slide Show

By Ms. Kelly's Fifth Grade Class

WEB PHOTO GALLERY

Introduction

Classroom photos are great things to share. But with the rising costs of developing film, or printing high-quality digital photos, it can get quite expensive for teachers to develop photos for their classes, or even print them from their computers. With the quick and explosive rise of the web, teachers now have a third option. Create a virtual photo gallery on the web!

The curricular objectives may vary for this activity. This technique allows for student work, research, event photos or any other image to be published quickly and easily on the web.

Appropriate Grade Level(s):

All

Subject Area(s):

All

Materials Needed:

Hardware: Camera (digital or 35mm)

Software: *Photoshop* Elements (or the full version), or *Photoshop* Album

Note: To publish your finished gallery on the web, you will need to collaborate with your school or district Webmaster. If that's you, then you need to have Internet access, an FTP (file transfer protocol) account on a web server (or online service) and FTP software (i.e. *GoLive, Dreamweaver, Front Page, Transmit, WS_FTP, Fetch,* etc.).

Filenames

Before running the web photo gallery action, rename the image filenames to something that better reflects what's shown in the image, rather than leaving them as "DSCN0047.jpg" or some equally useless name.

Activities:

1. Take photos of your project, student work, or event.

2. If you have a digital camera—upload the photos to your computer. If you are using a 35 mm camera, you can either have your photos developed and put onto CD, or scan them in using a scanner.

3. Edit your photos (removing red eye, rotating 90°, cropping, etc.).

WEB PHOTO GALLERY

Captions

As an extra step, you could give each photo a caption. Open each photo, choose **File>File Info**, and in the resulting window, enter the caption you'd like that image to have. Then, just choose **File>Save**, and continue on with your *Photoshop* action. When it comes time to create your web gallery, be sure to check the "Caption" box and uncheck the "Filename" box in the "Options: Large Images" section of the gallery settings. Note: you can get other lines of text (and begin new lines) by adding information into other File Info fields such as Title, Copyright and Credits. These will display as new lines of text with your info.

4. Create two new folders on your computer desktop. Name one "images" and the other "gallery." Save your edited images in an "images" folder. Leave the empty "gallery" folder untouched. If you would like your photos to display in your finished gallery in an order other than the order in which you took them, you should rename your images at this point. Add the numbers 01, 02, 03, 04 to the beginning of your image filenames to set a new order. If you'd also like captions for each image, see tip #3 for an optional step at this point.

5. Open *Photoshop*, choose **File>Automate>Web** Photo Gallery. In the resulting window pick the style of web page you would like to create (for instance, you can create a gallery with thumbnails of your photos in a table-like format, or vertically arrayed on the left side, or horizontally across the bottom of the web gallery).

6. Click on the **Choose** button to select your "images" folder with your saved photos. Click the **Destination** button to choose your empty "gallery" folder.

7. Under **Options: Banner** type the text you would like displayed on the top of every page of your gallery. This doesn't have to be the suggested text: "Site Name, Photographer, Contact Info and Date;" rather, it can be any four lines of text you would like to include.

8. The next three drop down panes found in the **Options** pull down menu allow you to set size of large and thumbnail images, identify background and header colors, and even add captions (tip #3). One thing you may want to change from the default settings is to uncheck the "Filename" box in the "Thumbnails" drop down pane. It can be distracting to see "DSCN0xxx.jpg" underneath each thumbnail image.

9. Click **OK** and let *Photoshop* work its magic. After a few minutes of automated activity, *Photoshop* will present you with the finished web gallery in your computer's default web browser. Check it to see that spelling and grammar are correct, all your photos are intact, and that you like the way your colors mix. If you need to change anything, just go back to *Photoshop*, choose **File>Automate>Web Photo Gallery** and make your changes. *Photoshop* will correct them and resave the files in the same "gallery" folder for you.

10. If you have access to a web server, just drag and drop your "gallery" folder to your web server. If you do not, save your "gallery" folder to a disk and give it to your web master for publishing. He or she should be able to give you a final web address (URL) for your published gallery.

WEB PHOTO GALLERY

Publishing Your Photos

If you plan on publishing any student photos on the web, be sure to get student permission first. Many parents may not want their students' images published to the world. A way to avoid this issue is to only shoot images from behind your students, never revealing faces. Also—it's a good idea to avoid including students' names on the same page as their faces, even if you have a signed parent waiver. If you must include student names, take a large group photo and list the names below. Just don't list the names in the order that they appear in the photo ("3rd row, l to r...." for instance).

Printing Your Photos

Another neat option, if you would like to print out various sizes of your photos, would be to use *Photoshop's* built-in Picture Package option (available in *Photoshop 6* or later, or *Photoshop Elements 2*). Go to **File>Automate>Picture Package (File>Print Packages>Print Package** in *Elements*). This tool allows you to print several sizes of a photo (or photos) on one page. Pick your file; choose your print package (for instance, you could choose to print one 5" x 7" and two 3.5" x 5" photos on the same page!) This is a great technique if you are looking to save money on expensive premium photo paper for your printer.

WEB PHOTO GALLERY

Examples

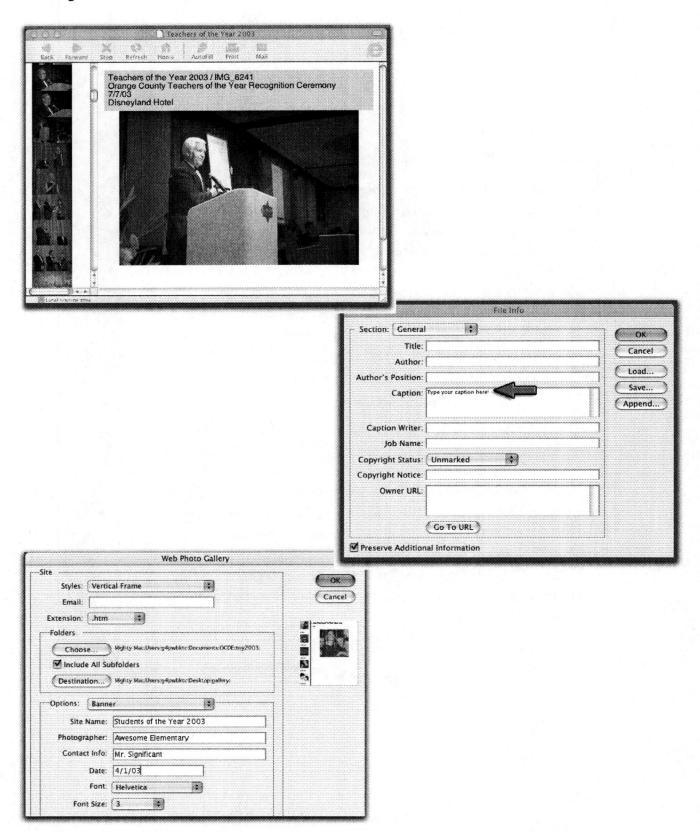

VISUAL STORYTELLING

Introduction

If pictures are worth a thousand words, students will rejoice in the opportunity to tell stories through digital images! This lesson works with most any curricular area, but is most fitting for a language arts/reading activity.

In this activity, students stage photographs of themselves acting out a scene (or scenes) from a story they've read. In preparation for their actual photo shoot, students need to work through several steps to develop their photographic retelling. Some very powerful conversations about what is most important in telling their story should develop in this process. By having students storyboard their project first, you can generate great discussion in each group of students. While not completely necessary, costumes are helpful, and painted or drawn scenery would also enhance the effect.

Appropriate Grade Level(s):

4–8

Subject Area(s):

English/Langage Arts

Materials Needed:

Hardware: Camera (digital or 35mm), color printer

Software: *Microsoft Word*, and *Photoshop Album*, *Photoshop* or *Photoshop Elements* (optional —only if you wish to retouch photos).

Activities:

1. Divide your class into reading groups of 3–5 students per group. Then give each group a different story to read. It's best to avoid picture books for this activity, as it could limit the students' creativity when choosing composing shots.

2. Students read their groups' stories, and write out the main points and morals (or theme statements). Groups discuss their observations and share with the class.

3. In groups, students identify which scenes (or moments) within the story would best portray the essence of the story's moral. To offer students a guideline, it would be best to give them a set number of scenes (I'd recommend between 3 and 6, depending on grade level, and number of cameras available). This activity could quickly escalate into a major time consuming project if students choose to compose too many shots.

One Story

One alternate version of this activity would be to choose one story instead of several. Depending on grade level and number of available cameras, it might make more sense for each group to cover the same story. Each group will inevitably come up with their own take on the story, in any case.

4. Assign a "director" for each shot. The remaining students in the group become the "actors" for that shot. This student is responsible for which characters are in the shot, who stands where, and how to best portray the action and/or dialogue taking place.

5. Print out the storyboard template from the CD-ROM for students to draw a rough storyboard for their story. Have them mock up an approximation of the shot composition, placement of characters, and write notes regarding the dialogue or action beneath their shot. Students should select a relevant passage from the part of the story that the shot represents.

6. Student teams should then work on pulling together any props they may need, set up backdrops and create mock-up costumes for their project.

7. Have the teams take turns using the camera to stage and shoot their story's shots. It would be highly recommended for teams to take multiple shots of each scene, just in case someone blinks, or some other unforeseen issue arises.

8. Depending on the availability of computers and time allowed for this activity, you could give students time to edit, crop, retouch and otherwise enhance their photos for their final storyboard.

9. Using the final story template found on the CD-ROM, have students place their photos in the boxes and retype the narrative passage from the story on the lines below. Print each team's photo-story (in color, preferably).

10. When done, each team presents their story as an oral presentation to the class. If the story is short enough, one narrator could read the entire story, with the students stepping up in turn with their photos. Otherwise, only the excerpts and the moral of the story are read, with each shot's 'director' reading his/her section of the project out loud.

Enhancing the Lesson

To further enhance this lesson, you can combine this activity with the Speech Bubbles activity on page 45. Students would then have to write actual dialogue for the characters portrayed in their images.

VISUAL STORYTELLING

Photoshop Skills

Given a little bit of time and *Photoshop* skills, you or your students could drastically change the appearance of the characters, setting, background, or even combine with other photos as a collage. The danger here is that you could spend hours working on individual photos, straying from the curricular purpose of the lesson. If you choose this option, be sure to announce limits to editing and enhancing time.

Storytelling Keepsake

As an extension to this activity, you could have the class pick one or two of the best illustrated stories and, using *iPhoto* (Mac OS X) or *Photoshop Album* (Windows), order a hardbound book of the story. Books ordered this way begin around $30 for a ten-page book, plus shipping and handling and sales tax.

VISUAL STORYTELLING

Final Story Template

POSTCARD CORRESPONDENCE

Introduction

In this activity, teachers from two different classes across town, the state, the country, or even the world can use a single camera in each class to take photos of trees, street signs, local flora and fauna, teachers, sights, and other local objects. These images can then be used as prompts for the letter (or e-mail) writing to students. In the case of e-mail, it is very simple to attach digital photos to the e-mail and send them off to each student's e-pal! No postage! This could be especially popular in middle and high school foreign language classes, allowing students to practice communicating in their e-pal's native language by sharing the sights of their own communities.

It's a great way to get students to write, to think about their lives, and about the lives of those in other cities, states or countries. What typically stalls the more commonplace pencil and paper "pen pal" model of this activity is often a lack of topics to discuss. In this activity, photos of their school, neighborhood, or home city to prompt conversation with their writing partner in the other class.

While it works best to begin this activity at the beginning of a school year, and continue throughout the year, it can work at almost any point in the year, and even with varying numbers of students in each class.

Appropriate Grade Level(s):

4–8

Subject Area(s):

English/Langage Arts, Social Studies, Foreign Language

Materials Needed:

Hardware: Camera (digital or 35mm), computer, printer (only if you use standard mail).
Software: E-mail access, *Microsoft Word* (only if you use standard mail).

Activities:

1. To start, contact with an interested colleague from another school and swap standard 'snail' and e-mail addresses. Even a school within the same district can be a good choice.

2. For the first e-mail, the two teachers should agree upon a topic for the photos. A good first topic is usually, "Tell us about your school."

3. Exchange class lists with the other teacher and randomly select students to pair up their "epals." If your class is smaller than the other, have the other teacher pair up some students to receive correspondence from one of your students. If you have more students pair up two of your students to send to one of your colleagues.

> ### Classroom Web Site
>
> A classroom web site can be a huge addition to this project. If each class had a web site to update with photos, stories, and other information, the correspondence could be greatly enhanced.

POSTCARD CORRESPONDENCE

4. Students take pictures of their campus and write a letter to accompany their image. For instance, someone might choose to photograph the playground, and describe his or her favorite playground activity in his or her letter.

5. Upload all student photos to your computer, rotate if necessary, and do any edits that could improve the photo quality. Finally name them with the students' names (i.e. jones1.jpg) and save as a copy.

6. Have your students write out their initial letters, then bring them to your computer one at a time to type them (if you have access to multiple computers, the students could type their letters in a word processing program, and then bring them to you on disk). After each student types his or her missive, show him or her how to attach the image to the e-mail, and then hit "Send." (See the following page for more information about sending.)

7. When the collaborating teacher receives your e-mails, he or she will print them out for the students, the other class will shoot their own pictures, and craft their own replies.

8. Set up a two-week turn around for the e-mails. This consistent pattern provides a regular writing exercise, and gives your students a chance to get a glimpse (literally) of another school community.

9. After each exchange, have the students select their favorite images from each batch of correspondence (see the following page for a neat idea using these photos). This can provide a great discussion about the other school, its students and their lives. You can ask good, in-depth questions about how your students perceive the students in the other class. How are their lives similar? How are they different?

10. The correspondence continues in this way, back and forth as a group. It would be best for you and the collaborating teacher to agree on an end date for the correspondence, so you can plan accordingly.

Retrospective Slide Show

The one or two images saved from each exchange can then be combined into a retrospective slideshow at the end of the year (see Classroom Slideshow lesson on pages 29).

POSTCARD CORRESPONDENCE

Sending E-Mail

You may find that your e-mail bottlenecks when you try to send too many e-mails with photos attached, as suggested on the previous page. If this is the case, you may have set your camera's resolution too high. Since some e-mail systems block your e-mail after 2-3MB, you'll definitely want to lower your camera's resolution to a lower setting. I would recommend something around 640x480 in size, at normal quality.

If you've already taken all your photos at a resolution that's clogging your e-mail box, all is not lost. There are many programs that will resize a folder of images automatically for you. Just point the program at your folder, specify the new resolution and convert. Here's a short list of some programs that do this, with their web sites and platforms:

1. *Blue Armadillo*—
 http://www.tech4learning.com/snacks/barmadillo.html
2. *Photoshop*—
 http://www.adobe.com/Photoshop
3. *iPhoto* (Mac OS X only)—
 http://www.apple.com/iphoto
4. *Graphic Converter* (Mac only)—
 http://www.lemkesoft.com
5. *Photoshop Album* (Windows only)—
 http://www.adobe.com/Photoshopalbum

Free E-Mail Accounts

Rather than sending the student e-mails through your own e-mail, you may want to consider setting up limit e-mail accounts for your students. Many web sites offer free classroom web-based e-mail and offer very good security and filtering tools. These sites protect your students from unwanted e-mail solicitations by several methods. The most common solutions are to limit the students' e-mail addresses from receiving any correspondence except from those addresses that you specify (you, the corresponding student, and the other teacher, for instance).

POSTCARD CORRESPONDENCE

Postcard template in *Microsoft Word*

Dear

POST CARD

SPEECH BUBBLES

Introduction

Do your students like reading comics? Then they'll love practicing their writing skills by creating their own dialogue for photos. Ideally, students would be provided a group of photos for which they need to write appropriate dialogue. You can choose to focus the lesson on any particular grammar or writing objective with which you are working—for instance, when you are introducing the use of adjectives, adverbs, interjections, pronouns, or prepositions. You'll find that interjections work particularly well with this activity, which can really motivate the emerging writers in your classroom.

Appropriate Grade Level(s):

6–8

Subject Area(s):

English/Langage Arts, Social Studies

Materials Needed:

Hardware: Camera (digital or 35mm), computer (two minimum), color printer

Software: *Photoshop* or *Photoshop Elements*

Activities:

1. Divide the class into groups based on your curricular topic. Each group should have one or two concepts they are required to illustrate.

2. Each group should plan out five individual scenes to demonstrate their concept. For instance, if the concept to be taught is interjections, students might plan to stage several instances in which a sudden exclamation would make sense. One example would be a scene in which a student is shown opening his backpack with a look of shock displayed on his or her face. Students will brainstorm what the student has discovered through the remaining "scenes."

3. Once each group has planned their staged shots, they take a least two pictures of each "scene." This will insure that they've got at least one usable picture with which to work.

Other Sources

This lesson would also work with images found from other sources, such as the web, textbooks, or photos that have been scanned into the computer.

Current Events

As an alternate activity, students could use images of current public figures. This could become an alternative to current events presentations.

SPEECH BUBBLES

Story Telling

To further enhance this lesson, you can combine this activity with the Story-Telling activity on page 37. Students would then write the actual dialogue for the characters portrayed in their story's shots.

Finishing Touch

As a finishing touch, students could put these images into a presentation, or print and post them on the classroom walls for display.

4. As each group takes their photos, they can then upload their pictures onto the computer and open them in *Photoshop* in order to add the speech bubbles.

5. As all cartoonists know, you should write your dialogue before drawing the encapsulating speech bubble. To do this, students will need to add a text layer with the character's (or characters') dialogue. Choose black as your text color. Click on the type tool; select your font and size, then click and drag to create a text box. This will force the text to wrap as it hits the edges of the text box.

6. Click and hold on the shape tool, and select the blob labeled "custom shape tool." This is the custom shape tool in *Photoshop*. On the option bar near the top, click on the triangle next to the shape selector, and click on the smaller, embedded triangle on the right of the toolbar to select "Talkbubbles."

7. Make sure that the options bar has "Fill Pixels" selected.

8. Draw the speech bubble in such a way that it is large enough to cover the entire dialogue. Once students have covered the text with the speech bubble, they can move the type layer above the bubble layer (as shown). In some cases, the speech bubble may need to flip 90° so that the arrow is pointing towards the appropriate speaker.

9. To finish the effect, click on the bubble layer, and add an inner shadow and bevel to the layer. Have your students save their work.

SPEECH BUBBLES

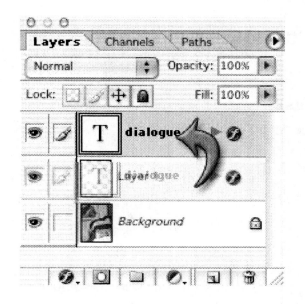

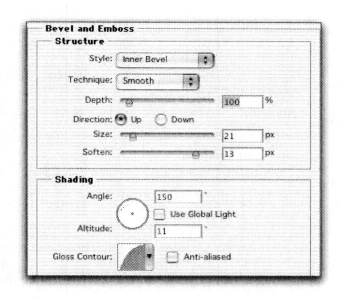

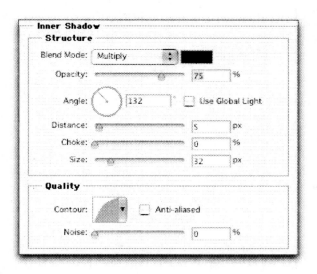

VISUAL WRITING PROMPTS

Personal Photograph

You could use your own digital photographs as visual prompts. If you take your camera on vacation, field trips and even everyday experiences, you would be surprised how many visually interesting photographs you could generate.

Macro Lens

Taking close-up shots of common objects is another way to create interesting and even surprising shots. Make sure your camera has a "Macro lens" built-in. Most digital cameras have a setting that allows you to take pictures within an inch or two of an object, for very interesting results. Who knew a flower petal looked like THAT close up?

Introduction

I've often found it difficult to motivate students to write creatively, even after being given an intriguing written prompt. Hanging inspirational or powerful imagery in your classroom is one way to move into the realm of visual prompts, but this can get costly very quickly. With the increasing number of schools and teachers connected to the Internet, literally millions of images are accessible to educators, for free! You can now use digital images as a writing prompt to trigger the creative juices for students. All teachers need to do is project or print these images out for students to view as a writing prompt.

After presenting an image to your class, you can have students write a paragraph, "quick write" or even a short story inspired by your visual prompt.

Appropriate Grade Level(s):

4–8

Subject Area(s):

English/Langage Arts, Social Studies

Materials Needed:

Hardware: Color printer, TV, or LCD projector, camera (optional)

Software: Web browser, Internet access

Activities:

1. Select a provocative, intriguing or visually stimulating image for your students.

2. Give the students their writing directions prior to revealing the image, as they may already be reacting to the image while you are reciting instructions.

3. Present this image on a TV or projector screen, or even your classroom wall.

VISUAL WRITING PROMPTS

4. Instruct students to begin writing according to the prompt. Do not allow discussion of the image prior to writing.

5. When writing time is up, you have a number of options, depending on your curricular goal:

 • Students could swap papers, and make observations on each others' writing.

 • You could facilitate a discussion about the image, what reaction it struck among your students, etc.

 • You could invite students to share their writing as a launch pad for discussion.

 • You could collect the papers and move onto a second image, repeating steps 1–4 of the activity.

Some great web sites for visual writing prompts can be found at **http://www.tech4learning.com**

Mortage

Alternately, you could present a montage of photos or art, using the sequence as a further push into student storytelling.

Aspiring Writers

You could also work through a series of images this way, drawing out different reactions from your aspiring writers, or having them tackle a range of writing styles or grammatical goals (avoiding run-ons and fragments, for instance).

VISUAL WRITING PROMPTS

SYMMETRICAL SELF-PORTRAIT

Introduction

In this activity, students, using close-up self-portrait as a starting point, analyze the concept of symmetry, as it is visible in the human face. They make measurements to determine the distance between the eyes, ears, nostrils, and the corners of the mouth. Students can compare their measurements with those of other students in the room to see how they vary among people. Once familiar with the concepts involved in symmetry, students slice their photos in half along the vertical center of their own faces.

Working with the remaining half only, students draw and color in the other side of their faces, using the photo as a guide. Since most human faces are not perfectly symmetrical, students will have a chance to see the perfectly symmetrical version of their own faces. This is quite a fun activity and can be used in preparation for an Open House or Back-to-School night. What parent wouldn't like to see a picture of his or her child hanging up in your classroom?

Appropriate Grade Level(s):

All

Subject Area(s):

Art, Math

Materials Needed:

Hardware: Camera (digital or 35mm), computer, printer, tripod.

Software: [optional] *Photoshop Elements* (or the full version of *Photoshop*).

Activities:

1. Attach a neutral colored piece of construction paper (preferably white) on a blank wall. Tape two lines on the floor near the wall: one for the students to stand on, and one to place the front two legs of the tripod.

2. Lock the camera in position on the tripod, so you don't inadvertently rotate or tilt the camera. The only motion that needs to be adjustable is the vertical height of the camera, usually adjusted with a hand crank (see inset). Adjust this crank to account for the varying height of your students.

3. Turn off your camera's flash. If you have a tall lamp or adjustable light source, place it behind you and aim it at the students' faces to act as filler.

Mirror Illustrations

As an extension to this activity, students can hold up a mirror in front of their noses and position the camera such that the mirror completes the hidden half of their face with a mirror image. Using this optical illusion as a comparison, students can evaluate how well they did with their hand-drawn versions.

SYMMETRICAL SELF-PORTRAIT

Printing

If you have access to *Photoshop 7* (or *Photoshop Elements 2.0*), you can save quite a bit of printing paper and ink. Rather than printing out one photo per page, you can print two 5" x 7", four 4" x 5", or even 9 wallet-sized images. Before printing out your photos, go to **File>Automate>Picture Package (or File>Print Packages>Print Package** in *Elements*). This tool allows you to print several sizes of a photo (or photos) on one page. Pick your file; choose your print package ([2] 5" x 7", [4] 4" x 5", or [9] 2.5" x 3.25" for instance), then click on each image to select a different student's photo. When you've got a different photo in each box, hit "OK" to create the file. Print. Repeat until you've printed all of your student portraits.

4. Take a photo of each student in your class, from shortest to tallest. Check each photo to make sure that their eyes are open before moving on.

5. Upload your photos to your computer. There should be no red-eye, if you turned your flash off.

6. Print out the photos.

SYMMETRICAL SELF-PORTRAIT

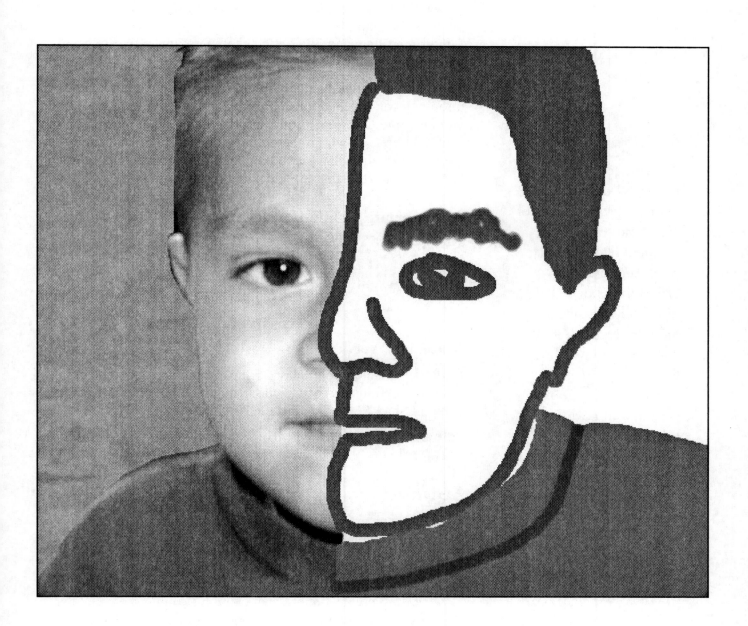

DIGITAL ART

Introduction

The powerful editing tools currently available to educators provide an invaluable way to introduce students to the work of the great artistic masters. Students can transform self-portraits or other photos into visual masterpieces, imitating the great artists of the Romantic, Renaissance, Expressionistic, Post-Modern, or other era or style. Working from almost any photo, students apply *Photoshop* filters and other effects to approximate the style and look of famous artists.

This kind of digital manipulation has become quite automated through recent releases of *Photoshop* and other editing tools. You will also find that students are surprisingly good at picking up the subtle differences within the options for each filter, and can quickly learn the software well enough to selectively apply filters to their photos to achieve the desired results.

Appropriate Grade Level(s):

4–8

Subject Area(s):

Arts

Materials Needed:

Hardware: Camera (digital or 35mm), computer (a computer lab could be used instead of the class computer, but only if every computer had *Photoshop* installed),

Software: *Photoshop Elements* (or the full version or *Photoshop*), or *Paintshop Pro*.

Activities:

1. Pick one artist for this activity, and review his or her most famous works with the class.

2. Group the students into pairs. Have each pair take a self-portrait, a still life, or another appropriate photo to use as a starting point. Import each pair's photo into the computer. Save a backup copy of all photos before moving on.

Filter Effects

You can combine filter effects by duplicating the background layer of the photo, applying different filters to each duplicate, and then adjust the opacity level of each layer. Place these layers such that the topmost layer has the lowest opacity setting, moving slightly higher with each layer towards the bottom, original layer.

DIGITAL ART

3. Using *Photoshop*, each pair works together, applying filters, effects, and other *Photoshop* tools to manipulate the images. The most commonly used filters for this activity are found under **Filter>Artistic and Pixelate**. One or two clicks, and your photo turns into art!

Eraser Tool

Photoshop's Eraser tool could be used to selectively paint back the original photo in some areas. This can help restore clarity to some parts of the photo that the artistic styles have obscured. Here are four simple steps to accomplish this cool effect:

1) duplicate the background layer of the photo,

2) apply the artistic filter(s) to the duplicate layer (now named "Layer 1"),

3) select the Eraser tool and an appropriate brush, and

4) while still on Layer 1, erase away those parts of the image that have become blurry or overly distorted.

DIGITAL ART

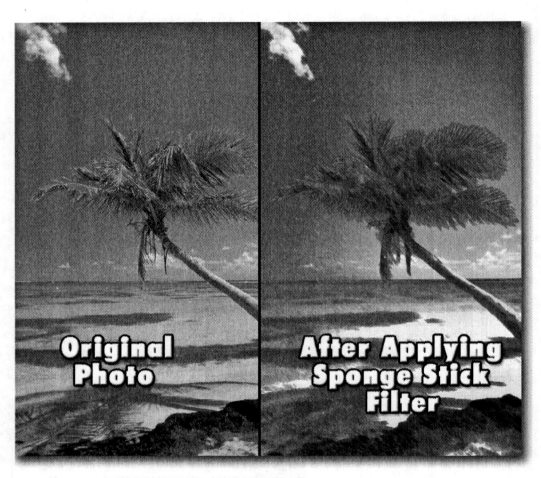

Original Photo

After Applying Sponge Stick Filter

Last Filter	⌘F		

Extract...	⌥⌘X	
Liquify...	⇧⌘X	
Pattern Maker...	⌥⇧⌘X	

Artistic	▶	Colored Pencil...	
Blur	▶	Cutout...	
Brush Strokes	▶	Dry Brush...	
Distort	▶	Film Grain...	
Noise	▶	Fresco...	
Pixelate	▶	Neon Glow...	
Render	▶	Paint Daubs...	
Sharpen	▶	Palette Knife...	
Sketch	▶	Plastic Wrap...	
Stylize	▶	Poster Edges...	
Texture	▶	Rough Pastels...	
Video	▶	Smudge Stick...	
Other	▶	Sponge...	
		Underpainting...	
Digimarc	▶	Watercolor...	
KnockOut 2	▶		

DIGITAL ART

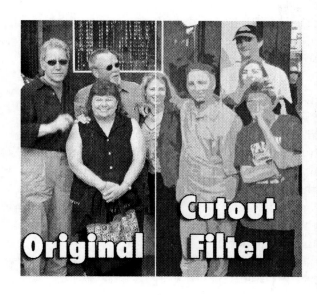

Original / Cutout Filter

Last Filter	⌘F
Extract...	⌥⌘X
Liquify...	⇧⌘X
Pattern Maker...	⌥⇧⌘X
Artistic	▶
Blur	▶
Brush Strokes	▶
Distort	▶
Noise	▶
Pixelate	▶
Render	▶
Sharpen	▶
Sketch	▶
Stylize	▶
Texture	▶
Video	▶
Other	▶
Digimarc	▶
KnockOut 2	▶

Color Halftone...
Crystallize...
Facet
Fragment
Mezzotint...
Mosaic...
Pointillize...

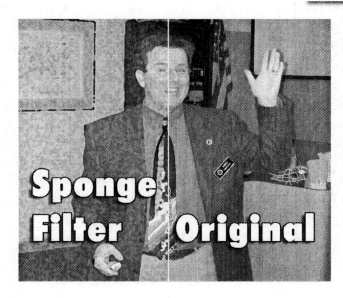

Sponge Filter / Original

　　　57

CAMPUS "CELEBRITIES"

Introduction

All schools have "celebrities." Every day, they come to school and do their jobs, with little or no recognition. They may not realize it, but they're celebrities. Students know them on sight, but how much do they *really* know about them?

In this engaging activity, students pair up, interview and take a picture of someone with a clearly identified role on campus (librarian, custodian, cafeteria worker, principal, nurse, last year's teacher, etc.). Each pair then writes 3–5 sentences about their "celebrity," describing their job duties, how long they've been doing it, and what they most enjoy about their work. Afterwards, they present their "exclusive interview" to the whole class. During their presentation, the pair uses the photo as a visual aid as they take turns reciting their sentences.

Appropriate Grade Level(s):

1–3 (would work for kindergarten as well)

Subject Area(s):

Language Arts

Materials Needed:

Hardware: Camera (digital or 35mm), computer, printer, tripod (optional), TV or LCD projector (optional).

Software: (optional) *Photoshop Elements* (or the full version of *Photoshop*).

Activities:

1. Brainstorm with your students to come up with some campus "celebrities" in your school community. Stop when you have between 10 and 15 names on the board (or less, if you have a small class).

2. Send a memo to those your class has selected, alerting them to the class assignment, and obtaining permission for students to interview and photograph them. Be sure to give them a way to respond with dates/times they would be available for their interview. Remember to follow up by providing them with a schedule so they can adequately prepare. Who would pass up the opportunity to be a campus "celebrity"?

3. Group your students into pairs (in some cases, trios). Have each group draw names from a hat until all celebrities are selected. If you have a small school, you can have multiple teams repeat with the same person.

School Web Page

If your school has a web page (or newsletter), you may want to alert your campus web master about your project, as the photos and interview responses could be a great addition to the site!

Visual Aid

Instead of printing out the campus celebrities' portraits, you could connect your computer or camera directly into a TV or LCD projector. Place this next to your students as they present, and you'll have quite a visual aid!

CAMPUS "CELEBRITIES"

4. Depending on the grade level, you may brainstorm interview questions with the students, or present your own list of questions. The younger the students, the fewer the questions (one or two per group member is a good rule of thumb).

Here are a few good starter questions:

a. What is your job title?

b. What do you do?

c. How long have you been on campus?

d. What's your favorite part of your work here?

e. When do you get to school?

Obviously, you'll want to review the questions being asked by the groups to make sure they don't ask embarrassing or overly personal questions (i.e. "How much money do you make?").

5. Generate a schedule of interviews to be done. Send this to all interview subjects and review with the student groups by having them practice asking questions of each other. Also be sure to have them practice listening and writing down responses to their question.

6. Over the next week or so, allow students to leave class for 10 minutes to conduct their interview and photo shoot.

7. Have the students or a parent volunteer immediately write down their celebrity's responses, and begin practicing their oral presentation.

8. Print the photos of your class celebrities.

9. Students take turns giving oral presentations about their campus celebrities, sharing their photos and taking turns reciting the answers to their interview questions.

Tripod

A tripod is recommended, as the hand-eye coordination necessary to take steady photos of tall adults could be quite a challenge for your students. It's also recommended that you have the subjects sit for their portrait. You could have a parent volunteer act as photographer for students as well.

Word Proessing

An alternate activity would be to have students import their photos into a word processing document and type their sentences.

CAMPUS "CELEBRITIES"

Save Paper and Ink

If you have access to *Photoshop 7* (or *Photoshop Elements 2.0*), you can save quite a bit of printing paper and ink. Rather than printing out one photo per page, you can print two 5" x 7", four 4" x 5", or even nine wallet-sized images. Before printing out your photos, go to **File>Automate>Picture Package (File>Print Packages>Print Package** in *Elements*). This tool allows you to print several sizes of a photo (or photos) on one page. Pick your file; choose your print package ([2] 5" x 7", [4] 4" x 5", or [9] 2.5" x 3.25" for instance), then click on each image to select a different student's photo. When you've got a different photo in each box, hit "OK" to create the file. Print. Repeat until you've printed all of your important people.

Can I Have Your Autograph?

As a follow-up, you could post the presentations on the walls of your classroom and invite the celebrity for an autographing session!

CAMPUS "CELEBRITIES"

Mr. Murphy

Mr. Murphy is our physical education teacher. He has been working at our school for three years. He teaches us different games and sports to play.

His favorite part of working at our school is helping kids feel good about their ability to play sports. He thinks that all kids can be good at sports if they have a positive mental attitude.

REPORT RESEARCH

Introduction

Students should not be limited to researching in encyclopedias, text books, and newspapers. Digital photography gives your students several more options! Not only can students incorporate images from the web, but they can also shoot their own photos as evidence to be used in research papers, reports, and other projects.

For instance, in a math class, students could break up into teams and take images of geometric shapes found in everyday objects, and bring them back into the classroom to present their findings. This can be especially powerful in middle school classes. Geometry or physics students could print out their images to measure the ratio of an object to its shadow, demonstrate the concept of slope using images that illustrate "rise over run," or use time-lapse images to show the change in a life-science experiment over time. All presentation software available allows for the import of .jpg photographs, from *Kid Pix* to *PowerPoint*.

Biographical research papers can benefit greatly from photos found on the web. Imagine having students insert images, essentially illustrating their own work in their research papers!

Appropriate Grade Level(s):

3–8

Subject Area(s):

All

Materials Needed:

Hardware: Camera (digital or 35mm), computer with Internet access, printer.
Software: none required, image-editing software (optional).

Activities:

1. Present your students with the report assignment, giving specific requirements, deadlines, grading rubric, and topic choices. After selecting his or her topic, each student (or student team, if you are doing group projects) identifies the essential question or problem within his or her topic. From this essential question, students can identify main points and arguments for their topic.

2. In the course of their research, students brainstorm images that they could used to illustrate each of these main points in their research project.

3. Cameras are distributed and students take photos illustrating their main point.

Inserting Images

Inserting images into a *Microsoft Word* document is best done by creating a text box first, then inserting the photo into the text box. Then, choose your text wrapping preference from the toolbar. This is the cleanest way to manage the text wrapping and alignment around text. If you are using Claris or *AppleWorks*, images can be inserted directly as images.

REPORT RESEARCH

4. For some research topics, digital photos can be obtained on the web through a powerful image search engine like Google (**http://image.google.com**), Lycos (**http://multimedia.lyscos.com**), or AltaVista (**http://image.altavista.com**). Students should write down citation information for each image they obtain in this way. Key information to capture: URL, photographer (if credited), and search engine used. See the Image Search tip for key information on search engine use.

5. Students insert their photos into a blank word processing document or their completed research paper, and type a caption below each image that will be used, to give it context and tie it to the point that it illustrates.

6. Depending on how you would like students to use the photos, you may have them print each relevant photo or web image to be included in their research or type their reports around the images.

REPORT RESEARCH

Image Search

When you are searching the Internet for images, it is crucial that you preview the students' search terms, and guide them to appropriate search engines. While nearly every school and district connected to the Internet has filtering software in place, searches do occasionally bring up unintended results. All three search engines mentioned in step 4 have a "safe search" or "parent control" mode that should be turned on for student-friendly sites. Direct your students to these search engines only. Alternately, you could pre-select web sites for students to browse based on their topics, and limit them to these sites alone. There are excellent services, such as netTrekker (**www.nettrekker.com**), that will (for a fee) provide you with teacher pre-evaluated sites.

Time-Lapse or Stop Motion Photography

If your students opt to use time-lapse or stop motion photography, a great choice for Mac OS X users is *iStopMotion* (**www.totallyhip.com**). If you don't use Mac OS X, either *Anasazi Stop Motion Animator* (**www.animateclay.com/download.htm**) or *Microsoft Movie Maker* (**www.microsoft.com**) could be used for stop motion animations. Both are free! For time-lapse photography, *WinTLV* (**www.demonweb.co.uk/c3sys/wintlv.htm**) will do the job for most Windows 9x systems, and it's also free!

This man is your **FRIEND**

Canadian

He fights for **FREEDOM**

FAMILY HISTORY

Introduction

Photos are a wonderful way to preserve the past. In this activity, students are asked to interview one member of their family and report what they've learned to the class. But instead of the more common oral presentation, students will use scanned in photos to enhance their presentation.

Not only will your students learn about their family histories, but they will also have a chance to present orally in front of their peers using presentation software.

Appropriate Grade Level(s):

4–8

Subject Area(s):

Language Arts, Social Studies

Materials Needed:

Hardware: Camera (digital or 35mm), scanner and TV or LCD projector.
Software: Appropriate scanner drive, and *PowerPoint* (or some other presentation software).

Activities:

1. Give students a list of suggested questions to ask one member of their family members. Review the list with your students to make sure they understand the questions, and how to record their subjects' response. A sample list is available on the CD-ROM.
2. Have students select a family member, schedule a time to interview them them record their responses. Have them both sign the bottom of the interview form.
3. Next, they collect between three and five photos of their family member from the family albums, or photo boxes. If these are already in a digital format, they can bring them on disk! If not, they will scan them at school and return them home.
4. Students return to class with their interview notes and family photos.
5. Review with your students how to scan photos onto the computer, and rotate them as necessary.

 a. Relationship to student d. Career
 b. Childhood e. Interests/Hobbies/
 c. Education Miscellaneous.

Using Presentation Software with Students

Often when you have students use presentation software, you may find that the many multimedia features, fonts, and background graphics they can choose from are distracting. A common strategy to keep them on task is to direct them not to change fonts or colors, add any graphics, images, transitions or sounds until they had the required number of slides full of content. In some extreme situations, you can even confiscate each computer's mouse until students had the required number of slides with content! If you think about it, you don't really need the mouse to type.

7. If you have access to a computer lab, or you have multiple computers in your classroom, students can work simultaneously on their presentations. If not, have your students take turns on a computer, creating their slide show. They should create title and closing slides, plus a slide for each of the five categories, inserting their photos when appropriate. A template for this presentation is included on the CD-ROM.

8. Have students print out an outline of their slideshow (or the 3 slides per page view in PowerPoint) and write notes for what to say for each slide on this outline.

9. Set up a computer connected to the TV or an LCD projector. If your students used more than one computer to create their presentations, be sure to transfer them to this computer prior to the big presentation day.

10. Have each student practice with a partner, refining their presentation.

11. Finally, have each student present their "Family History" in front of the class, using their notes as a guide.

Extension Idea

- One of the very popular uses of digital photography today is as a mechanism to record and share the members of a family tree. Documenting one's genealogy is a great way to get students interested in historical events as they discover family ancestors who possibly fought and became heroes in major world conflicts. Or they may discover the relatives who established "firsts" in family history (first person to fly in an airplane; first family to own a television; first family member to graduate from college).

 A more simple variation on this idea is to use a graphic organizer to represent the family tree. Scan in photographs of as many family members as there are photos available. Arrange the photos in a word document or tree template to show each family members' relationship to the others. Label the "tree" with names of family members as well as the dates of their birth and death, if known. (See example)

Templates

Another tool that is helpful in guiding students in the creation of a presentation is a template. All they need to do is fill in the blanks. You can easily pre-load the same presentation file onto every computer in your class or a computer lab. Once there, students open the file, choose **File>Save as...** and rename it with their own file names.

Billings Family Tree

Charlie Chenault Billings
Married to Mig Billings
May 10, 1925

Eleanor Bloom

Patricia Spencer

Mary Ware Bullock

PROCEDURAL WRITING

Introduction

There are many types of writing. One of the most commonly forgotten when giving writing assignments is procedural writing. This is a "how-to" form of writing used in writing manuals and instructions. As anyone who has read an instruction booklet or flyer can attest, pictures make the task of following directions much easier.

In this activity, your students will write and illustrate instructions for a procedure. This activity can be done individually or in pairs.

Appropriate Grade Level(s)

All

Subject Area(s)

All

Materials Needed:

Hardware: Camera (digital or 35mm), computer, printer, tripod, and (optional) TV or LCD projector.

Software: any photo editing software, *Photoshop Elements* (or the full version).

Activities:

1. Show the class sample illustrated instructions (you can pull many good examples from assembly instructions for furniture, car manuals, etc.). Lead your students through a discussion of how the images assist in explaining the process.

2. Brainstorm a list of school or classroom activities that could benefit from illustrated instructions with the class. If you would like students to take pictures at home, you can also brainstorm procedural activities they might do there.

3. Have your students pick a topic for which they will write instructions. Begin by having them write out their procedural steps. Each set of instructions should have between 4–10 steps.

Topics

You can use just about any topic for this activity, as long as it is appropriate to the age level. For instance, "how to make a peanut-butter sandwich" would be a good primary topic, while "how a bill becomes a law" might be more appropriate for upper grades.

4. Next, have them pair up with a partner and exchange lists. Even if it's the materials are not at hand, have each student walk through their partner's instructions without their assistance. This will help the students refine their instructions. Once both partners have had a chance to get feedback, give them time to edit their instructions with improvements. Depending on the success of the first round if testing, you may want to give your students one more round of "field testing" and enhancing the instructions with different partners. By this time, students should begin to realize just how difficult it is to write instructions.

5. Students can now read through their own instructions, deciding which steps would be improved by the addition of images. Each set of instructions should have no more than 3–5 images. Collect a copy of each student's set of instructions and their proposed photos.

6. Upon your approval of their proposed photos, students can collect any necessary materials from home and bring them to school the next day.

7. Students pair up once again and assist their partners in taking their photographs. Depending on the number of digital cameras to which you have access, this could be a long process, as each team takes turns using the camera(s).

8. Once the photos have all been taken, you or your students upload them to your computer, crop them (3" x 4") and print them.

9. Have students write their instructions and attach their procedure's photos to the appropriate steps to their worksheet. They may crop out unnecessary parts of their photos.

10. Students use their own instructions with all necessary materials to complete their procedures as final oral presentations. You could then place all students' procedural instructions into a folder as a presentation of what they have learned.

Illustrated Assembly

As an alternate intro activity, you can work through a set of illustrated instructions with your students to assemble something for the classroom, or another activity of your choosing.

PROCEDURAL WRITING

Place the food on the counter.

Then place the turkey on the bread.

First, go to the refrigerator to get turkey, mayonnaise, lettuce, and bread.

Spread the mayonnaise on the bread. Be careful with the knife!

PROCEDURAL WRITING

Place the second piece of bread on top of the lettuce.

Tear off the lettuce and place it on the turkey.

Enjoy your sandwich!

ELLIS ISLAND JOURNAL

Submitted by Meryl Wolf

Introduction

In this project, students learn about the immigrants who came to this country between 1860 and 1900—where they came from, why and how they came, and their experiences on the journey and arrival in America. With digital media, students can get access to actual records from Ellis Island. In addition, this project will enable students to make practical use of technical skills including word processing, searching the Internet, importing illustrations, documenting sources (both online and in books), and using online encyclopedias.

Students will be responsible for answering all the questions, completing the project within the scheduled time, using the computer and books as resources, supplementing this with any information they can obtain from family members via interviews, documenting their sources, writing clear information, and making a presentation to the class. In addition, students will create a flag of their immigrant's country of origin.

Appropriate Grade Level(s)

Fourth

Subject Area(s)

Social Studies

Materials Needed:

Hardware: Computer with Internet access
Software: *Microsoft Word, AppleWorks,* or another word processing program that allows for the importing of images; *Internet Explorer, Netscape Communicator,* or another Web browser

Activities

Direct students to create their journals using the information that they have found. Have them add graphics to illustrate their journals. Tell them to insure that their journals answer the ten questions below.
Students should imagine that they are immigrants who have just arrived in America. They should create journals of their experiences that will answer all ten of the questions below.

1. Who are your family members?

 - How old is each person?
 - What are your names?
 - What are their trades or occupations?

International Festival

If possible, conclude this project with an international festival and have students present their journals. Have them choose representative foods that they can bring in to share.

2. What country have you come from?

 • What money (currency) do you use?

 • What foods do you eat?

3. Why is your family leaving their homeland behind and risking so much to live in this new country?

4. Describe your experiences on the ship.

 • How long was your journey?

 • What were the conditions like?

5. What prized possessions did each of you bring?

 • Why did you choose to take those things with you?

6. Describe each of your emotions when you first saw America.

7. Describe your experience going through immigration.

 • Did you go through Ellis Island?

 • What inspections did each of you have to go through?

 • What types of problems did each of you face?

8. Where will your family live?

9. How will your life be different in America?

Describe:

 • how you will communicate with other people.

 • the foods you will eat.

 • the money you will use.

10. Think about all you have been through to risk coming to this country. Explain your feelings and thoughts.

ELLIS ISLAND JOURNAL

Text Wrapping

Click once on the picture to select it. Select a type of wrapping such as square or tight. Small white circles will appear around the picture. Notice the green circle along the top of the picture. Dragging from here is how you rotate the picture. Explore other text wrapping choices to see how the words rewrap around the picture. Try the behind text to see the word go on top of the picture.

Inserting a Picture

To add a picture from the Internet into your document, right-click (or control-click if you are using a Mac) on the picture. Choose either Copy or Save Picture As (choose a location to save the picture).

If you copied the picture, switch back to Word from your taskbar and paste the picture (Edit, Paste). If you saved the picture from the Internet, choose Insert, Picture, From File. Locate the picture file and double-click it to insert it onto your document. (Remember, if your picture is covering up some text, just turn on test wrapping so the words wrap around the picture, or set the picture behind the text.)

Adding Clip Art

To add a picture to your document from the clip art collection, first click the mouse to position the cursor where you want the picture to be inserted. Next, choose Insert, Picture, Clip Art or click the Insert Clip Art button on the drawing toolbar. Word XP's new Insert Clip Art task pane will now appear on the right side of the screen. Type a keyword(s) in the Search box at the top, then press enter.

Scroll through the choices. When you find a picture you like, either click once on the picture, or drag and drop the picture to your page. The picture will now appear in your document in line with the text.

Click once on the picture to select it, then resize it by dragging in or out from one of the resizing handles (boxes around the outer edges). Drag from a corner to keep the picture in proportion.

ELLIS ISLAND JOURNAL

It was a long journey. The ship was so crowded with people that we could barely move.

WINTER CELEBRATIONS

Submitted by Brunetta Allen

Introduction

In this project, students learn about various cultures and how they celebrate their winter holidays. As they learn, they will develop an appreciation for different cultures. helping them learn to appreciate other cultures. They are divided into groups and assigned a winter holiday by the teacher.

Some possible celebrations to research are Hanukkah, Kwanzaa, Ramadan, Christmas traditions in a variety of countries, New Year celebrations in a variety of countries, and the Chinese New Year.

Appropriate Grade Level(s)

Third and Fourth

Subject Area(s)

Social Studies

Materials Needed

Hardware: Computer with Internet access
Software: *AppleWorks, Kid Pix,* or *Microsoft Word*
Other: Winter Celebrations Research Sheet

1. Have students access the Internet to research the winter holiday assigned to their group. Their research should answer the questions on the Winter Celebrations work sheet.

2. While students are doing their research, they should try to find photos online that illustrate their findings and save them to their computers.

3. When students have finished their research, have them create posters on their computers. The posters should have pictures and reports about what they learned.

4. Have groups present their posters to the class.

Saving vs. Copying Images

When students find photos from the Internet that they want to add to a presentation, they have the option of saving them to their computers and inserting them into their documents, or simply copying and pasting them. While students may be tempted to copy and paste because it is easier and takes less time, it may be a good idea for them to take the extra step and save the photos to their computers. That way, if anything happens to their posters, they can easily re-create them without going back on the Internet to search for their photos again.

Winter Celebrations Research Sheet

Name: _____

Holiday to research: _____

- In what country or countries is the holiday celebrated?

- What are some traditions the holiday has?

- Are there any songs or stories?

- Is there special food that is eaten?

- Is there special clothing worn?

EFFECTIVE ELEMENTARY SCHOOL BEHAVIOR

Submitted by Vivian Demko

Introduction

Students always need to learn about the rules and routine of the classroom and school. This project allows them to have a visual representation of the rules they need to follow. At the end of this project, each student will be provided with a book about the rules of the school with himself or herself as the "star" of the book. Students will have the books available at their desks to refer to during the school day.

Students will be assigned partners. Students will be responsible for taking at least seven digital photos of their partners following a rule. Students will use the photos of themselves to make books that are at least seven pages long. Each page will have a photo of the student following the rule and a written description of the rule.

Appropriate Grade Level(s):

Early Elementary

Subject Area

Social Studies

Materials Needed

Hardware: Camera (digital or 35mm), computer, and necessary cables

Software: *Microsoft Word* or *AppleWorks*

Other: List of classroom and school rules

Activities

1. Have students take pictures of their partners following classroom or school rules. Some possible photo opportunities include:

 - Sitting quietly at desk doing "seatwork."

 - Reading on the carpet.

 - Sitting at the computer.

 - Requesting help at the computer.

 - In the morning: Hanging up bookbag and coat, doing lunch count, getting started on morning work.

Get Close to Your Subject

Remember that you want to be able to see detail. If you are too far away, your subject will get lost. Use the best camera angle. If you have time, walk around and look at your subject from several different angles. Try taking the shot from below your subjects. You will see face detail better. See how the photo changes as you move around.

Classroom Buddies

If students have classroom buddies in upper grades, have them use pictures of their buddies as models for their behavior.

- Walking quietly in the hall. (Right side of hallway, hand off walls, not talking, etc)

- Getting lunch in the cafeteria: Lining up, paying for lunch, getting tray, and sitting down.

- Going to the nurse: Checking in with nurse and waiting quietly for help.

- Going to the office: Greeting the receptionist and asking for help.

2. If you have a digital camera—upload the photos to your computer. If you are using a 35mm camera, have the photos developed onto a CD or scan the photos into your computer.

3. Have students open *Microsoft Word* or *AppleWorks* and start creating their books.

4. Have them add a picture to the beginning of each page. Below the picture, they can type a description of the rule.

5. Have them add a page break in between each page.

6. When students have finished their books, allow them to print their pages. Have them staple their pages and keep them at their desks to refer to when they need them.

Placing Photos in Tables

If you are using *Microsoft Word*, try placing your pictures inside tables to keep them from moving around on the page. To do this, go to the **Table** menu and select **Insert Table**. Create a table with one row and one column. Insert your photo inside the table. You can center the table on the page and resize it to fit your photo.

EFFECTIVE ELEMENTARY SCHOOL BEHAVIOR

- When you are at the computer, work quietly and stay on task.

- When you have finished your work, you can sit quietly and read a book.

ALL ABOUT ME

Submitted by Laurie Patterson

Introduction

As the school year begins, students are just starting to learn about their classmates. This project will help them learn more. Students work in pairs to take pictures of one another. They then write about themselves using correct punctuation and capitalization and include photos for a classroom display.

Appropriate Grade Level

First through Third Grade

Subject Area

Language Arts

Materials Needed:

Hardware: Camera (digital or 35mm), computer, and necessary cables

Software: *AppleWorks* or *Microsoft Word*

Other: All About Me Work Sheet

Activities

1. Have students complete the All About Me work sheet with answers about themselves.

2. Direct students to take a picture of their partners.

3. If you have a digital camera—upload the photos to your computer. If you are using a 35 mm camera, you can either have your photos developed onto a CD or scan them in using a scanner.

4. Students can open a new document in *AppleWorks* or *Microsoft Word.* They should type the sentences they completed on their worksheet into the new document.

5. Have students check their sentences to make sure that their spelling, punctuation, and capitalization are all correct.

6. Insert each student's photo into his or her document.

7. Have students print their pages. Add them to the bulletin board.

Taking Your Photo

When you are taking your photo, make sure that you select a simple background that is free of clutter. Of course, if you find clutter later that you didn't see while you were shooting the picture, you can always crop it out, but you can save some time by starting with a good, clean background.

Good Lighting

Avoid putting your subjects into shadows or in a mix of bright lights and shadows. Avoid taking pictures when your camera is pointed into the sun or toward a window. This will make the person in your photo look darker and it might add some distracting shadows. If you need to, you can use your camera's flash to illuminate the person. Remember that most flashes have a range of 8–10 feet.

ALL ABOUT ME

All About Me Work Sheet

1. My name is _____.

2. I am _____ years old.

3. My favorite food is _____.

4. My favorite color is _____.

- -

All About Me Work Sheet

1. My name is _____.

2. I am _____ years old.

3. My favorite food is _____.

4. My favorite color is _____.

All About Me

My name is Henry.

I am six years old.

My favorite food is chicken.

My favorite color is green.

PLANT GROWTH AND DEVELOPMENT

Submitted by Laurie Patterson

Introduction

In this activity, students use a digital camera to record the life cycle of plants. They use Brassica Fast Plant seeds (available from **http://www.fastplants.org**), which complete their life cycle in about 40 days.

Students will plant the seeds in individual containers along with a supporting stick. Plants will then be placed under the grow light. Each day, students will measure, photograph, and study the changes in the plant. Students will work in groups of two to make slide presentations of the development of their plants.

(**Note:** Although this activity uses Brassica Fast Plant seeds, it can be completed with any kind of seed. The time frame will simply be longer.)

Appropriate Grade Level(s)

Third

Subject Area(s)

Science

Materials Needed

Hardware: Camera (digital or 35mm), computer, and necessary cables
Software: *AppleWorks* or *Microsoft PowerPoint* and *Microsoft Excel*
Other: seeds, pots, soil, supporting sticks, grow light
 Plant Growth and Development Work Sheet

Taking Your Pictures

Have students try to take pictures of their plants at the same time every day. They should also take their pictures from the same angle and make sure that the lighting and shadows stay the same. This will make their slide shows even more impressive, because it will look almost like an animation of the plant growing.

Activities

1. Have students get pots, soil, and seed and plant their seeds, adding a supporting stick in the pot. They can work with their partners to take photos of the seed planting process.

2. Have students complete the Plant Growth and Development work sheet.

3. Students should measure their plants each day. They should include the measurement in an *AppleWorks* or *Microsoft Excel* spreadsheet as well as take pictures of their plants every day. These plants grow very fast.

4. Work with your partner to create an *AppleWorks* slide show or *PowerPoint* presentation of your plant, including information about the stage and what is expected in that stage. They should be sure to include their spreadsheet growth charts in their slide shows or presentations.

PLANT GROWTH AND DEVELOPMENT

Plant Growth and Development Work Sheet

Name: _____

What are the seed leaves?

What are the true leaves?

What is the function of the roots?

What is the function of the stem?

What is the stamen?

What is the pistil?

Day 1

• On Monday, September 22, we planted our seed and watered it.

SCHOOL TOUR BOOK

Submitted by Diane Vorndran

Introduction

When young students first start school, they can become overwhelmed with the new environment. With this project, they can tour the school building and meet the support staff. Taking digital pictures and creating a book of the experience provides a valuable class resource that students can visit again and again.

Appropriate Grade Level (s)

First through Third Grade

Subject Area(s)

Social Studies

Materials

Hardware: Camera (digital or 35mm), computer, and necessary cables

Software: *Microsoft Word* or *AppleWorks*

Activities

1. A great time to do this activity is in the first week of school. Take the students on a tour of the building. If possible, visit the office, principal's office, assistant principal's office, health room, gym, cafeteria, library, art room, and computer lab.

2. During the tour, introduce each member of the support staff and take a picture of him or her. Explain to students what each person's job is.

3. After the tour, download the pictures onto your computer (or scan them if you are using a 35mm camera).

4. Share the pictures with the students. Divide them into pairs and assign each pair a staff member. Have them write two sentences about that person's job.

5. Import the photos into *Microsoft Word* or *AppleWorks*. Type the name of the staff member and the students' sentences underneath each picture.

LCD Screen

Before you take your tour, decide if you really need to use the LCD screen when you take your pictures. It uses up quite a bit of the camera's battery power. Just to be safe, you may want to bring extra batteries along if you decide to use your LCD screen.

Capturing Action

Capturing action adds interest to your photo. Try to anticipate the action and try to press down the shutter part way down as you are anticipating the shot. That way the camera does not have to waste time focusing.

Mr. Limon

- Mr. Limon is our school secretary. He helps all the parents and students who come to our school.

MY VACATION

Introduction

Here is a variation on the well-known, "What I did over winter break" paper that nearly every student is asked to write as school starts back up in January. Before they leave on vacation, let students know that they will be writing on this topic when they return. Encourage them to take pictures of whatever activities they engage in over the break. These pictures can be taken using one of the new disposable Kodak digital cameras that can be purchased at any grocery store or drugstore. The processed pictures are returned to users on a CD. But any photos taken with any disposable, digital, or 35mm camera today can be delivered on a CD just as easily. Students just need to remind their parents to ask the developer to include a CD along with any prints they may be requesting.

Appropriate Grade Level(s):

Third Grade and Up

Materials Needed:

Hardware: Digital or 35mm camera

Software: Any presentation software (*PowerPoint, Kid Pix, AppleWorks*) or word processing software (*Microsoft Word, AppleWorks*)

Activities:

1. As part of the homework assignment, suggest that students take at least one picture a day chronicling how they spent their time over vacation. Give them a few examples, such as:

 a) If they are taking a trip, students should include a fun shot of the family members that would show their departure: picture of a packed car, or the family in front of their house waving.

 b) Remind students to take pictures of "destination landmarks" as they travel: the road marker that names the city and population can be fun if they go through small, out of the way towns. Well-known or well-celebrated cities and towns often have unique or interesting signs welcoming you to their city.

MY VACATION

c) Likewise, students should definitely remember to take pictures of any monuments, homes of famous people, museums, gravesites, or places of interest that they might visit.

d) If not traveling, students should take quick photos of typical events in their day including chores that they may perform at home: feeding a pet, raking leaves, etc. A "before and after" picture of their room on the day they decide to clean might be fun!

2. When the students return to school, have them select three or four of their best shots to write about. These can help guide and structure the writing of their thesis as the photos mark the beginning, middle, and end of their time off.

3. The pictures can be imported into a presentation program (*PowerPoint, Kid Pix SlideShow, AppleWorks*), imported into a *Word* document, or can simply be printed and pasted on writing paper or into a memo book as an ongoing journal writing project.

My Summer Vacation 2003

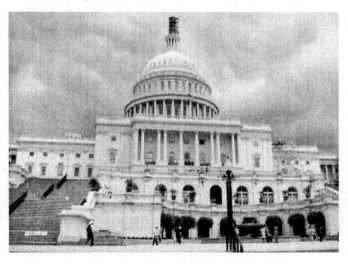

My family traveled to Washington D.C. this summer. We got to visit the Capitol Building where the laws of the United States are passed.

Steps

Defining the steps in a process is a common writing practice in both the elementary and middle grades. Have students record the series of steps in an event. Here are some ideas:

- How to cut a fresh pineapple

- Executing a perfect golf swing (students could label the photos to indicate the ideal position of the arms, elbows, feet, and hips)

- Steps in building a birdhouse or making a paper airplane

- Steps in changing a baby's diaper

As they write out the steps in their chosen process, students can illustrate the most important steps with the photos taken.

PICTURE STORIES

Student Pictures

Remind students that if they are using digital cameras, they should take more pictures than they will need so that they can choose the very best pictures for their stories.

One Page Story

Another method of doing this activity would be to import all pictures into a *Microsoft Word* table. Create a table with a cell for each picture. Students can type a sentence or two of their stories below each picture. The table will automatically expand to fit all the text.

Introduction

One picture can tell a variety of stories, depending on who is looking at it! In this project, students exercise their creativity as they look at a series of pictures and decide on the story that they tell. These can be pictures that the students take themselves or pictures provided by the teacher. Students can import the pictures into a word processing or presentation document and practice their typing skills by adding the text of their stories below the pictures.

Appropriate Grade Level(s):

Third Grade and Up

Materials Needed:

Hardware: Digital or 35mm camera

Software: Any presentation software (*PowerPoint, Kid Pix, AppleWorks*) or word processing software (*Microsoft Word, AppleWorks*)

Activities

1. If students are taking the pictures for this activity, allow them enough time to take the pictures and bring them to school.

2. Upload the photos into your computer, either from a digital camera or a CD.

3. Show students the pictures in order.

4. Have students write on paper the stories that they think the photos tell.

5. Import the photos into a word processing or presentation document. Add one photo per page.

6. Have students write their stories under the pictures.

7. Print their picture stories or show them as multimedia presentations.

PICTURE STORIES

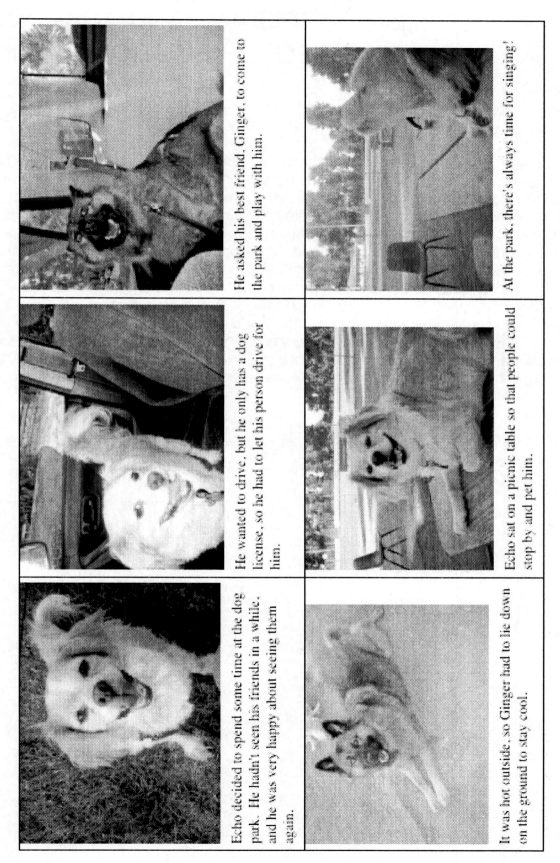

He asked his best friend, Ginger, to come to the park and play with him.

At the park, there's always time for singing!

He wanted to drive, but he only has a dog license, so he had to let his person drive for him.

Echo sat on a picnic table so that people could stop by and pet him.

Echo decided to spend some time at the dog park. He hadn't seen his friends in a while, and he was very happy about seeing them again.

It was hot outside, so Ginger had to lie down on the ground to stay cool.

RELEASE AND ASSIGNMENT
(FOR EXECUTION BY MINOR)

TO: **Your District**
 001 Address
 City, CA ZIP

You or your authorized employee, representative or agent have taken or plan to take on or about _____ videotapes, motion pictures, audio recordings, and/or photographs of me (all of which are herein called Pictures). With respect to all such Pictures, and any reproductions of same in any medium, for valuable consideration, I hereby irrevocably: (a) consent to and authorize the use of by you, or anyone authorized by you, of their use, reproduction, distribution, sale, and exhibition for any purpose and in any medium whatsoever, including (but not by way of limitation) the sale, publication, display and exhibition thereof for educational purpose and for, promotion, advertising and trade, without any compensation or notice to me, (b) consent to the use of my name, and (c) grant and assign to you the right to secure copyright throughout the world in your name, or otherwise on the Pictures and any reproductions of same in any medium, (d) release, discharge and acquit you from any claims, demands or causes of actions that I hereinafter have against you by reason of anything contained in such Pictures and reproductions thereof or in the advertising or publicizing thereof.

This instrument shall ensure to your benefit, as well as to the benefit of your subsidiaries, affiliates, license, successors an assigns.

Signature of Person

Address of Person

Witnessed by:

Signature of witness

I represent that I am the (parent) (guardian) of the above named person. I hereby consent to the foregoing on (his) (her) behalf.

Dated _____

School _____

Teacher _____

STORYBOARD

Period _____

Date _____

Names _____

Storyboard

STORYBOARD

Date _____ Period _____

Names _____

Storyboard